猫

بی خلاف مسلمان عود هندی بود طبیعت آن کرم و خشک ست در سیوم نوعی سی

اسود دهد جون بیاشامند و بر آن ضماد کنند مسور بیارسی کربه کویند

فر ودی اکه هندی بود و بنهایت کرم و خشک بود و بنهایت

مسخن بود و قایم مقام فرد تغلب بود و شریف کنید

جون و یراهمینان لیسوزند دردیکی بیکی کرفته کمو خاکستر

کرد با سرکه بیامیزند و طلا کنند به یوم مرغ

برشقاق که درمیان انکشتان دست و پایها بود

زایل کند و خافقی کوبند کوشت وی کرم وتر بود و منفع بود و جهت در در ابو آسیب و مسکین نکرده

در ولپث را نافع بود و سنکبویه مکبنویه برث و کفته شد صور خان در مصر عنک خورند

در عراق لبغه بربری و بیونانی فلجیض خوانند و بعضی

بلبوسا و بعضی افیمارون بود که اندرون و بیرون سفید

و اکه سرخ و سیاه باشد بد باشد و جبیش بن الحنی

کوید طبیعت وی کرم ست در اول درجه سیوم و خشک ست

در اول درجه دوم و بعضی کویند خشک ست در سیوم

و کویند سرد ست در دوم و در وی قوتی بود که مسهل

بلغم بود و خاصیت که در وی تسکین درد مفاصل و نقرس کند و حذر در زبان بیند و میکند

The
Well-
Read
Cat

Pierrette Crouzet-Daurat

Paola Gallerani

&

editorial direction

iconography

Khadiga Aglan

graphic design

& layout

Paola Gallerani

translation

Isabel Ollivier

editing

Andrew Ellis

ISBN BNF : 978-2-7177-2469-1 ISBN OL : 978-88-89854-56-3

MICHÈLE SACQUIN

The Well-Read Cat

From the Bibliothèque Nationale de France

Preface by Pierre Rosenberg

{BnF | Bibliothèque nationale de France

OFFICINA LIBRARIA

Handwritten annotations:

Dearest 阿女末:,

Wish your years will be filled with more and more wonderful moments!

Please forgive what seems a hasty gift!

Happy 22nd Birthday :)

And Suli

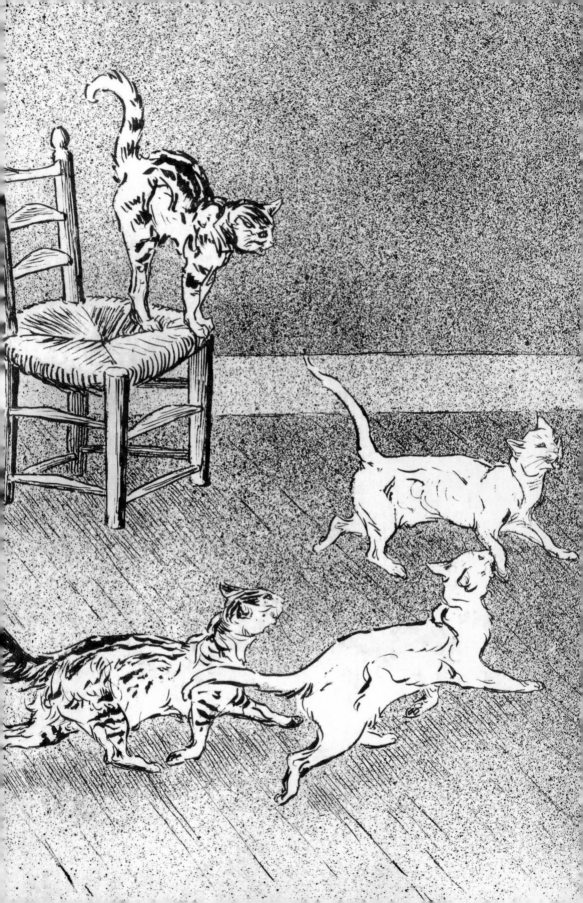

Table of Contents

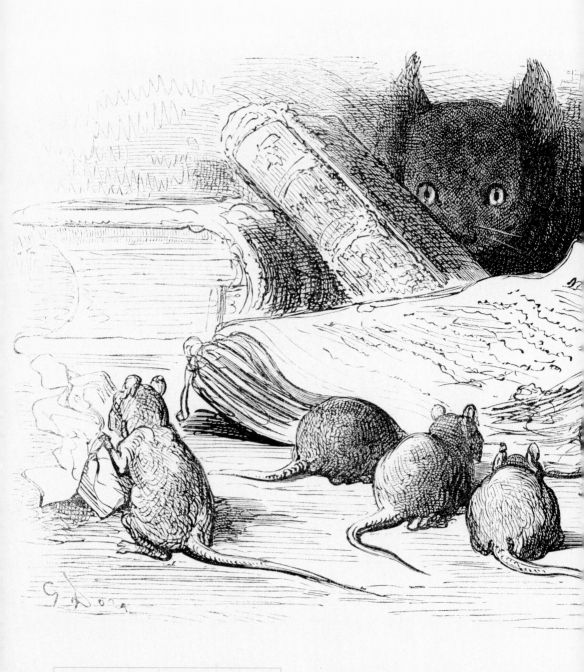

♣ "The Cat and the Mice", engraving after a drawing by Gustave Doré (1832–83) for La Fontaine's *Fables*, Paris, 1868

Estampes et Photographie, DC-298 J, t. 10 (1)

Preface

In my house I want:
A reasonable woman,
A cat passing among the books,
And friends in every season,
Whom I cannot live without.

GUILLAUME APOLLINAIRE, *"The Cat"*,
Bestiary or The Parade of Orpheus

To my cat Rome (1997–2010), who has just left me

Were there cats in the Royal Library in the old days? How did the librarians of the time fight against mice? What did they do to ward off the ferocious rodents? I have no idea. But I do know that the present-day Bibliothèque Nationale de France, on both its sites (Rue de Richelieu and Quai François-Mauriac), houses thousands of cats of all breeds, from all countries and all centuries. They have just one thing in common – they are mostly paper cats.

Paper cats! Cat lovers will be up in arms. Paper cats… Let us say, cats on paper, which is not so mortifying. On all sorts of paper: bible paper, rag paper, newspaper, drawing paper or laid paper, tracing paper or photographic paper, Bristol board or cardboard, without forgetting parchment, vellum and, of course, the coated paper that cats love to lie on – as all cat-lovers know.

9

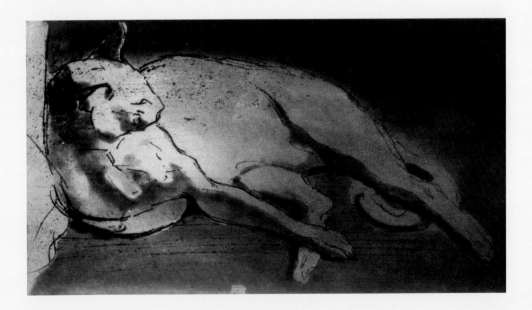

❖ "The Cat", Raoul Dufy (1877–1953), woodcut for *Le Bestiaire ou Cortège d'Orphée* by Guillaume Apollinaire (1880–1918), Paris, Deplanche, 1911
Réserve des livres rares, RES G-YE-266

♣ "Sleeping Cat", Théophile Steinlen (1859–1923), engraving
Estampes et Photographie, DC-385 FOL, t. 2

I owe the feline breed an apology. I have often been harsh on painters' cats (or cat-painters) because painters and cats alike have fallen short. Not to mince matters, painters have often messed up their cats. The list of painters who have done justice to cats is short. Only a few have the knack of portraying them (Chardin and Bonnard come to mind), whether occasionally or obsessively. Painters may paint fast but cats are faster still. Painters may paint slowly, but cats have endless patience and their timeless immobility tries the patience of any painter.

On paper, things somehow shake down, as this book abundantly proves. Cats are *papergenic* – or, to be learned, *cartogenic* – just as they are said to be photogenic. Remarkably successful portraits of cats, moving or funny, friendly or cruel, tender or tough are to be found in all periods and all regions, even the most remote. They are tucked away in a corner or, on the contrary, parade centre-stage, but they are often just a pretext for some suggestive anecdote.

The illustrated inventory of the cats in the Bibliothèque Nationale de France has yet to be compiled, and I do not know whether advances in technology – Gallica or Google – will ever enable us to finish the task. Perhaps the foretaste served up here will tempt some intrepid computer geek to launch into the adventure? I doubt it. In the meantime, we will make do with admiring the imagination of the creators of cats on paper, whatever their origins, through the scholarly but companionable work of Michèle Sacquin, chief curator in the manuscripts department, who has intelligently woven text and illustration into a sweetly instructive book.

The cat is ambiguous, and feelings towards it have always been ambivalent: there are diehard cat-lovers, dire cat-haters and cool customers in between. Fortunately, the cat haters have now

Mon cher ami Henri,

puisque vous voulez bien me faire une place
dans votre collection d'autographes, je pense
que cette page vous donnera une idée assez exacte
de mon écriture.

Eug. Lambert

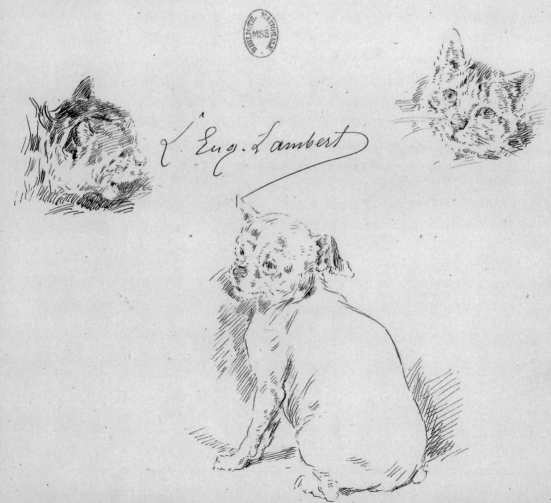

❧ "A Cat, a Dog and a Genet", Hans Bol (1534–93), miniature in *Preces*, illuminated manuscript, Antwerp, 1582

Manuscrits, Latin 10564, fol. 12, detail

❧ "Fauna: the Cat", Djamâlî Yazdî, illuminated manuscript, India, 17th–18th century

Manuscrits, Supplément persan 1568, fol. 33

fallen silent and books on cats are the preserve of cat lovers, whether they write or read them. Both often "own" real-life cats. Are their cats true to their paper image? (I am embarrassed to have to use the word "true" which is, rather unfairly, seldom applied to cats.)

And that is where Michèle Sacquin has surprises in store for us. She has selected such a range of images that we never weary of them. There is the domestic cat cosily ensconced at home and the wildcat stalking its prey in a hostile world; there are sanctified, sacred and baleful cats; a voluptuous cat and a playful cat, a treacherous cat and a trusty cat; the poet's cat and the alchemist's cat, the cat that slinks in the shadows out the scorching sun, and the familiar cat warming itself by the hearth; there is the inveterate thief, and the cat that looks as if butter would not melt in its mouth; the cats of the Annunciations and those of Baudelaire; nameless cats and famous cats; thousands of caricatures of cats; the realistic cat and the stylised cat; cats in fancy dress and seven-league boots and lean alley cats; the cat that talks and the cat that sings; the cat that hunts for food or sport; there are "European" cats and pedigree cats; tomcats and kittens (all simply adorable, of course!); there are rangy cats and erotic pussies (take it as you please), who do not all date from the eighteenth century and may be Japanese, and then the cats of innocent childhood…

If you will excuse the long list – although the inventory is far from exhaustive – I would just like to check a few points in Michèle Sacquin's book. First of all, the cat's steady social climb. It has shaken off the bad reputation it owed to so many ancient authors – adorable La Fontaine, contemptible Buffon… In other words, its faults, or to be politically correct, its "faults" are now not just excusable but actually acceptable because they are held to be inherent in its nature.

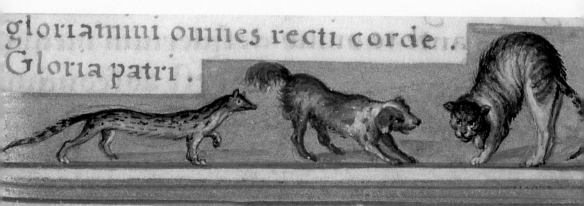

gloriamini omnes recti corde.
Gloria patri.

بخود و کشید و دست بر سر ها و اعضای او می مالید نا دست برد که او را بنهاد جو بالا بکر رسید محکم بگرفت

و خویشتن را بالش او بنهاد و با او مجامعت نکرد و او را ها نکرد و ماند و و چنده خاصیت هست

اگر او را کبی باخشک کنند و بکدر هنگ هنگ بیند و او را افکند و بخورد سود دارد و لبر را

دل برکند و در سر او سود او ارد و اگر خون کبی را بخورد رنگ لنگ شوند با

گویند که کربه جانوری بود

سخت غریب دوست

چنانکه اگر کسی غریب بود

در خانه زود و وران خانه

که بود بر امن آل غریب

کرد و درکس را آورد

و نخجید باشند و مرد در وی در مالد بعد سبک که مار غریب دشمن است و بنس چشم کربه

عظیم فروغ دهد و گویند که دوستی ار بوی سداب بکبر زد و از انش نترسید و اکربینی کربه

بروغن و خاکستر ما لند دیوانه شود و او اگر خواهند که بربانک بکبد بشت دست کربه

بروغن چرب کنند تا بلیسید آن مشغول شود و هر که کربه بربانی کنند و بخورد

دائم این در ست باشند و هر که شکنبه راسوما بهد کربه بربانی کنند و بخورد و دیوانه هند

Who would dare write these days that his cat was selfish!

But its social ascension demanded concessions and compromises. As it went up in the world, the cat lost its claws, its fleas, its smell and its sex. Alas, its plaintive yowling and amorous growling is no longer to be heard on Paris rooftops. Neutered, the tomcat has become a lap-cat.

As I said, the cat no longer hunts for food and its legendary independence has not gained by it. Certainly, it is still free (just think of the dog…). But its freedom has taken a new tinge. The cat has picked up habits and obliges us to fit in with them. But this is a fool's game: interdependence is not quite the same as independence…

Each cat is unique and cat-owners notoriously wax eloquent about them. May they beware if their neighbour at the dinner table cares for nothing but cobras or macaws… I have one, a black cat, which prowls the neighbourhood construction sites at night. He drags heavy work-gloves back home and lays them delicately on the doormat, notifying me of his find with a strange hoarse and rather unpleasant sound. Who can explain this caprice? Or tell me why his companion lazes on the heater while he prowls? Innate or acquired? I will not venture on to that treacherous ground, and in any case I have strayed far from this "Well-Read Cat" which I am pleased to preface.

Purring or silent, vacant yet clearly there, the cat is a book-lover. And, to judge by the extensive literature on cats, books have returned the compliment. I do not claim to master the subject, far from it, or even to have read the main part of this vast production. But if there is one book I particularly recommend, although it is little known in France, it is Christabel Aberconway's *A Dictionary of Cat Lovers*, published by Michael Joseph in London in 1949. I hope that there will be a French edition of it some day because the complicity between the author and her model is heart-warming. I would not forgive myself, of course, if I did not mention the *Dictionnaire amoureux des chats* by Frédéric Vitoux, another fanatical cat-smuggler.

❖ "The Academician Cat", François Coppée (1842–1908), letter to Méry Laurent (1849–1900), 14 August 1890
See also the text by Michèle Sacquin, p. 182.
Manuscrits, NAF 17357

❖❖ "Sleeping Cat", Théophile Steinlen (1859–1923), engraving
Estampes et Photographie, DC-385 FOL t. 2

Illustrators – artists, printmakers, or photographers – use cats for all ends: moralising, philosophic, iconographic, political, ironic, mocking, advertising, purely picturesque and illustrative, or symbolic (lust, sloth…). Sometimes even just to celebrate their beauty (I shall not attempt a definition of such a subjective notion as beauty…). But illustrators have (almost) always sought to serve the cat. Sometimes they succeed, more often at least than writers do, or at least than this writer, who is forced to admit that "the cat has got his tongue"…

Pierre Rosenberg
Académie française

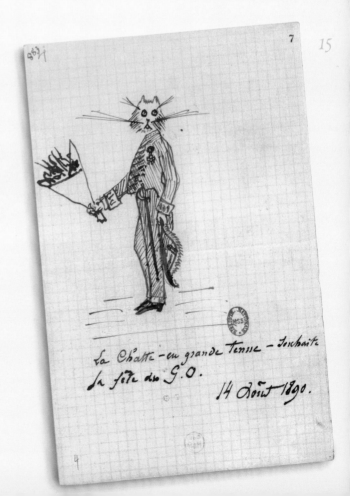

à Eug

66 There was something wrong
with the animals:
their tails were too long, and they had
unfortunate heads.
Then they started coming together,
little by little
fitting together to make a landscape,
developing birthmarks, grace, flight.
But the cat,
only the cat
turned out finished,
and proud:
born in a state of total completion,
it sticks to itself and knows exactly what it wants.
Men would like to be fish or fowl,
snakes would rather have wings,
and dogs are would-be lions.
Engineers want to be poets,
flies emulate swallows,
and poets try hard to act like flies.
But the cat
wants nothing more than to be a cat,
and every cat is pure cat
from its whiskers to its tail,
from sixth sense to squirming rat,
from nighttime to its golden eyes. 99

Pablo Neruda, *Ode to the Cat*
(trans. Ken Krabbenhoft, Boston, Little, Brown & Co. 1994)

The History of the Cat

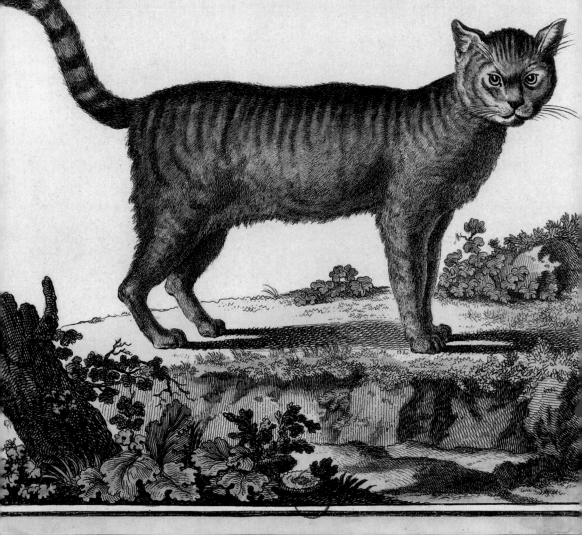

LE CHAT SAUVAGE.

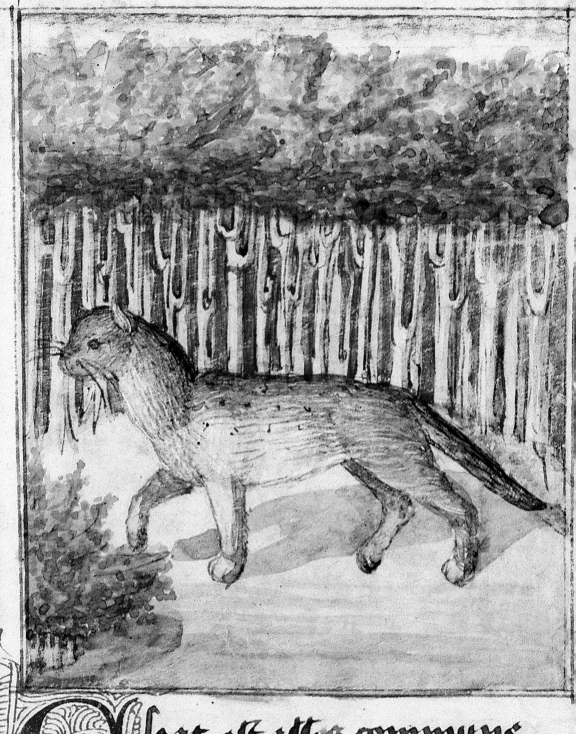

Chat est asses commune
beste. Si ne me conuiel
ja due de sa facon que pou de

*U*ntil the twentieth century the domestic cat was thought to be a descendant of the European Wildcat, *Felis sylvestris*, perhaps crossed with feral cats, that is, domestic cats that had run wild. Such crosses were thought to be frequent – as Daniel Defoe remarked in *Robinson Crusoe* – but have proved to be rare, and seldom fertile. In fact, the ancestor of our domestic cat, *Felis catus*, is the African Desert Cat, *Felis libyca*.

The history of the domestication of the cat – its acculturation as cat-fanciers would say – is still hazy. We know that the Egyptians tamed cats four or five thousand years ago because they feature on mummies, sarcophagi, statuettes, and frescoes. They then spread through the ancient Greek and Roman worlds, probably faster than has been thought. In the fifth century BC Herodotus talked of the Egyptians' love for cats, Xenophon and Aristotle described the animal, and Pliny the Elder included it in his *Natural History*. Recent archaeological discoveries show that the domestic cat probably began its conquest of Europe during the first millennium BC and was already well established there in the early years of the Roman conquest. There are references to cats in India in the twelfth century BC in the *Laws of Manu* (Mânava Dharma Sâstra), a sacred cosmogonic text written down in Sanskrit four centuries later. Yet there are few pictures, perhaps because the cat was conspicuous by its absence when Buddha died, surrounded by all the plants and animals in creation. From India, cats spread to China and then Korea before reaching Japan, where they were worshipped as much as in Egypt.

Cats were domesticated for utilitarian purposes, as the little feline quickly proved to be an efficient predator of the rodents which ruined crops and spread disease, a fact well known in ancient times and forgotten for much of the Middle Ages. It was also an excellent snake-hunter, a skill much appreciated in hot countries.

❧❧ "Wild Cat", Louis Legrand, engraving after a drawing by Jacques de Sève (1742–88), for Buffon's (1707–88) *L'Histoire naturelle* (*Les Quadrupèdes*), Paris, Imprimerie Royale, 1749–67
Estampes et Photographie, JB 24 (1) 4°

❧ "Chat sauvage", miniature in Gaston Phoebus's (1331–91) *Le Livre de la chasse*, illuminated manuscript, 1445–50
Manuscrits, Français 1291, fol. 25, detail

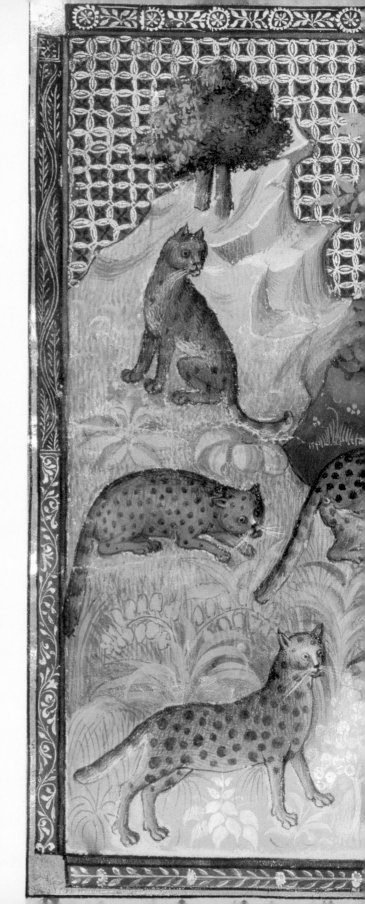

22

❧ "Wild Cats", miniature in Gaston Phoebus's (1331–91) *Le Livre de la chasse*, illuminated manuscript, 14th–15th century
Manuscrits, Français 616, fol. 36

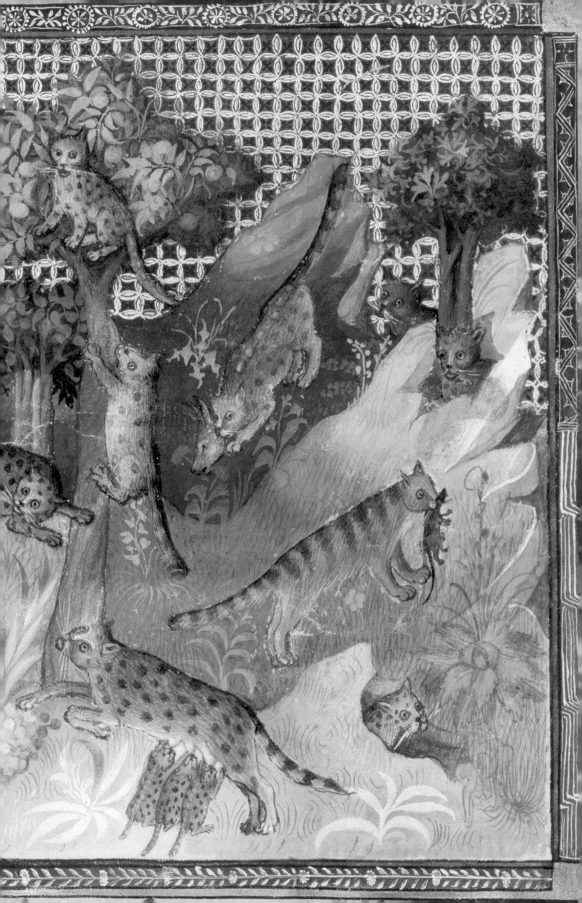

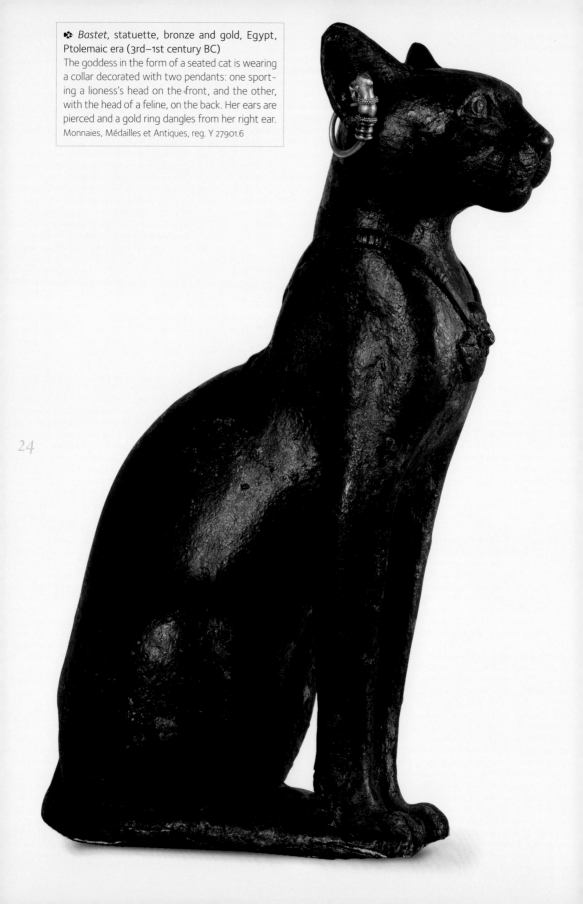

❖ *Bastet*, statuette, bronze and gold, Egypt, Ptolemaic era (3rd–1st century BC)
The goddess in the form of a seated cat is wearing a collar decorated with two pendants: one sporting a lioness's head on the front, and the other, with the head of a feline, on the back. Her ears are pierced and a gold ring dangles from her right ear.
Monnaies, Médailles et Antiques, reg. Y 27901.6

omestication was quickly followed by sacralisation. Between the nineteenth and sixteenth centuries BC the cat became an attribute of Bastet, the moon goddess who presided over childbirth, and later of the Greek goddess, Artemis.

At the same time cats were associated with the God Eamonn-Ra and consequently with the sun. At Bubastis and Heliopolis, cities consecrated to Bastet and Ra, sacred cats were raised in the temple confines. They were sometimes sacrificed with the idea of magnifying the animal, as an incarnation of the god, in a spirit very different from the popular fury that drove the massacres perpetrated in Europe from the Middle Ages to the Enlightenment. The early years of Christianity were not a bad time for cats, because the new religion condemned animal sacrifices. Cats had their place in monasteries: catching

mice in the granaries, curled up in the scriptorium, where manuscripts were written and illuminated, and even companionably installed in the monks' cells. Monks and nuns were not to be distracted from their devotions, so keeping a cat as a pet was often decried in moralistic texts in the Carolingian period, or even prohibited by some monastic rules.

The little feline has always been appreciated in the Islamic world perhaps because of the legend that Muhammad cut a piece off his burnous rather than disturb his cat, Muezza, who had fallen asleep on it. In Buddhist monasteries in the Far East, cats were

✿ First scene in the roll of *Litanies de Rê*, papyrus, Thebes, 12th–11th century BC
Manuscrits, Égyptien 159, detail

not ostracised in any way. Legend tells that the Sacred Cat of Burma was first bred by monks.

In Japan, as in Egypt, the cat was associated with the moon and fertility – like the white fox with which it is often represented – and was welcome in Shinto temples. The Japanese and the Chinese preferred the hare as a symbol of fertility in their lunar calendar, while the Vietnamese chose the cat.

In medieval Europe, the cat did not figure in the biblical bestiary, at least in the canonical texts although it appears in the apocryphal gospels, and sometimes in representations of Noah's Ark. Nonetheless, it is frequently depicted in religious iconography, but usually in a negative role. In Annunciations, such as the *Annunciation to the Shepherds* (see p. 29), it represents Satan threatening Redemption, and a fight between a cat and dog symbolised the struggle between good and evil, deceit and loyalty.

❖ "Noah entering the Ark", miniature in Pierre Le Mangeur's (ca. 1100–79) *Bible historiale*, translated from Latin by Guiard des Moulins in 1294, illuminated manuscript, Paris, 14th century
Manuscrits, Français 159, fol. 13

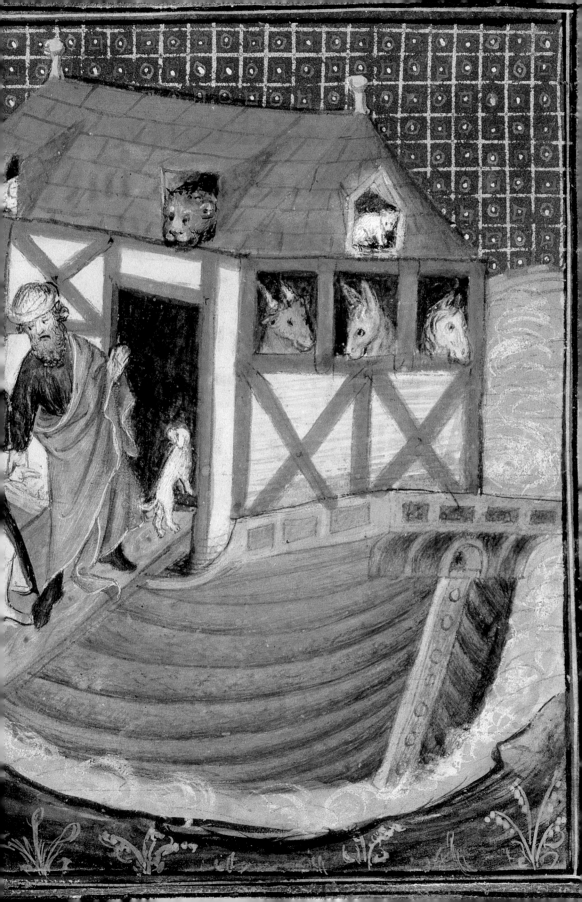

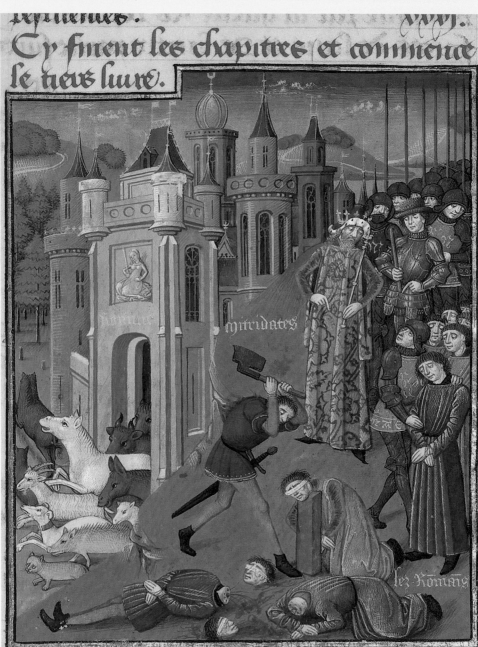

❧ "The Animals Leaving Rome before the War of the Allies" (on the left), Maître de l'échevinage, miniature for Saint Augustin's *Cité de Dieu*, translated by Raoul de Presles, 15th century

Manuscrits, Français 27, fol. 64v

❧ "Annunciation to the Shepherds", miniature in Justinian's *Digeste*, illuminated manuscript, Bologna, 1330

Manuscrits, Latin 14341, fol. 262v

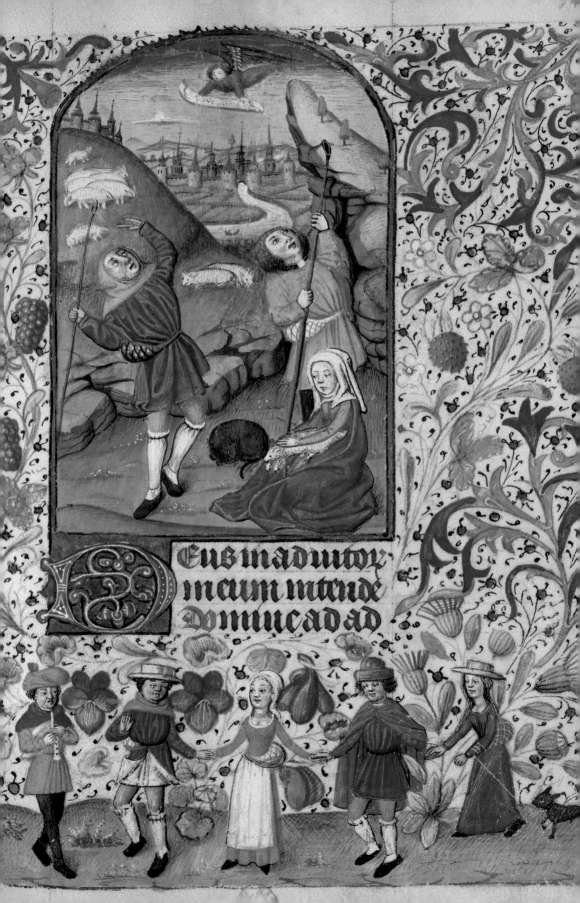

Eus madutou
meum intende
Dmmeadad

pud Græ-
anicè gá-
fat. An-
apud Al-
quod no-
o, & Ara-
us fignifi-
bi pro ca-
dixi, ine-
ftat, quo-
s de æluro,
n originis
uiuerram
Aegyptij
ius: Hinc
Aegypto:
at: facras
t infra di-
.8, cap.3.)
s accipi ui
s appellat
n noxiáq,
antè, Phi-
is & Colu
uidetur,
nquit, quæ
turus uel
la. Sed de
Meles a-
Te id quod
n appellat,
in Enarra-
aũt Var-
12, ubi fic
ta è mace-

ut tectorio tecta fint, & fint alta. Alterum ne feles, aut meles, aliáue

*T*he thirteenth-century encyclopaedists accurately described the eyes, whiskers, and claws of the domestic cat and its various types of fur. Authors included Bartholomaeus Anglicus, who wrote *De proprietatibus rerum* in Paris about 1230, Dominicans, such as Vincent de Beauvais, who compiled *Speculum naturale* for the education of Saint Louis, and Thomas de Cantimpré, the author of *De naturis rerum*. They pondered over its behaviour – its mating habits, hunting skills, the way it curled up by the fire or washed itself – and frowned on its immodest postures (see pp. 130–31).

With the rediscovery of Greek texts, zoology enjoyed a revival during the Renaissance. The cat was now widespread and provided a likely subject. "The cat is a familiar domestic animal known to all," wrote the Swiss doctor and naturalist Conrad Gesner in his *Historia animalium* (1551), illustrating his text with a picture of a tabby cat which was regularly reprinted by later writers, such as the Englishman Edward Topsell. In Italy, the Bolognese Ulisse Aldrovandi (1522–1605) and the physicist and astrologer Gerolamo Cardano (1511–76) drew a rather flattering portrait of the domestic cat. However like many later writers, Gesner pointed out the health risks: its fur could cause asthma and its breath was poisonous. This idea was taken up by d'Alembert and Diderot two centuries later in an article in the *Encyclopaedia* which advised cat-owners accustomed to kissing their cats on the nose to be careful.

Long before the English poet T.S. Eliot joined the fray with a famous poem ("The Naming of Cats" in *Old Possum's Book of Practical Cats*, 1939), the animal's name was subject to controversy. The Greek name *ailouros* meant "the animal that moves its tail". The Arabic term *cattus* replaced the Latin *felis* and even *ailouros* from the fourth century AD. Yet, Isidore of Seville, in his *Etymologiae* in the sixth century, found the term incorrect, and scholars preferred composite words based on *mus*, Latin for mouse. *Felis* did not reappear until the Renaissance.

❖ "The Cat", engraving for Conrad Gesner's, *Historiae animalium, liber I, de quadrupedibus viviparis...*, Tiguri (Zurich), C. Froschoverum, 1551
Réserve des livres rares, RES S 331 t. 1, p. 345

❖❖ "Decorated initial with cat and mice", *Bible*, illuminated manuscript, Bologna, ca. 1267
Manuscrits, Latin 22, fol. 317v, detail

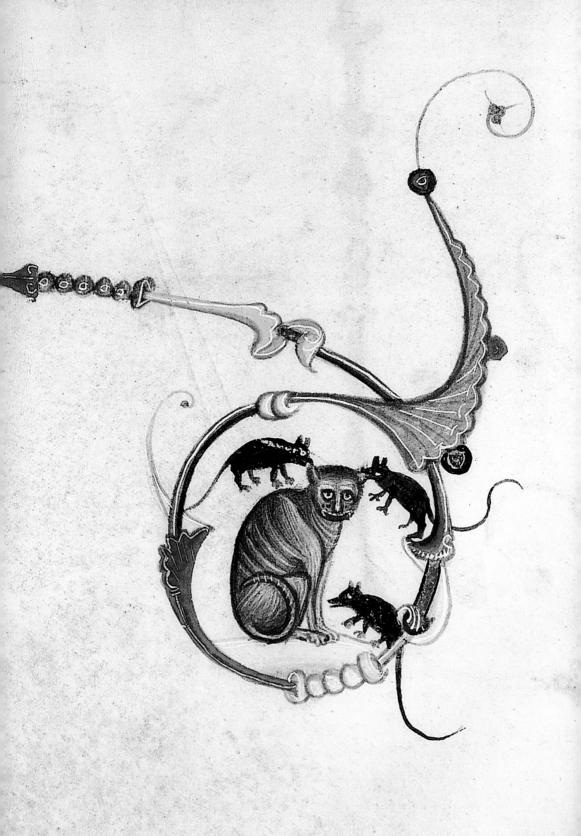

Seldom depicted outside bestiaries before the thirteenth century, the cat then appeared in marginal illustrations, often in the company of a mouse, or a monkey, its partner in crime since Aesop. The theme of the war of the cats and the rats enjoyed lasting success from the fifteenth century, especially after the ravages of the Black Death. It was used in seventeenth-century prints parodying the siege of Spanish-occupied Arras in 1640 (see pp. 34-35 and p. 67). In the same vein, Lope de Vega published his *Rimas humanas y divinas* in 1631, which included *La Gatomaquia* or "The War of the Cats", a burlesque epic and one of the great works of Castilian literature.

♣ "A Cat and a Monkey", atelier of Liévin van Lathem, margin illustration for Raoul Lefèvre's *L'Histoire de Jason*, illuminated manuscript, Bruges, late 15th century
Manuscrits, Français 331, fol. 35v, detail

♣ "A Cat and a Mouse", Maître des Très Petites Heures d'Anne de Bretagne, margin illustration in *Le Livre de richesse* (texts from the Gospel), illuminated manuscript, ca. 1490
Manuscrits, Français 9608, fol. 11v, detail

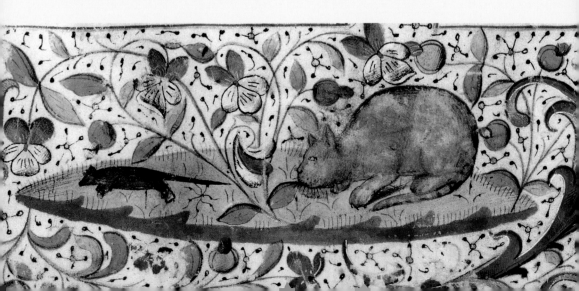

34

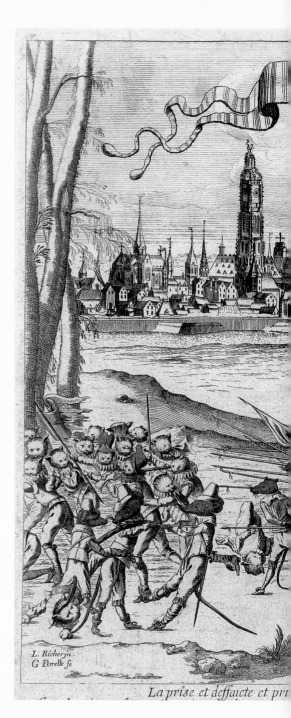

♣ "The capture, defeat, and surrender of the Spanish Cats by the French Rats before the town and city of Arras", 10 August 1640, Gabriel Perelle (1603–77), etching after a drawing by L. Richer, Paris, G. Jollain

On 9 August 1640 when the French were laying siege to Arras, the Spanish wrote on the city gate: "When the French take Arras, mice will eat cats." After their victory, the French changed one word so the jibe read: "When the French surrender Arras, mice will eat cats."

Estampes et Photographie, Réserve QB-201 FOL t. 32

♣♣ "Cats and Mouse", 15th-century woodcut in Rudolf Zacharias Becker, *Gravures en bois des anciens maîtres allemands, tirées des planches originales recueillies par Jean Albert de Derschau, publiées avec un discours sur la nature et l'histoire de la gravure en bois*, Gotha, 1808

Estampes et Photographie, Réserve EA-71 FOL

L. Richer jn.
G. Perelle sc

La prise et deffaicte et pri

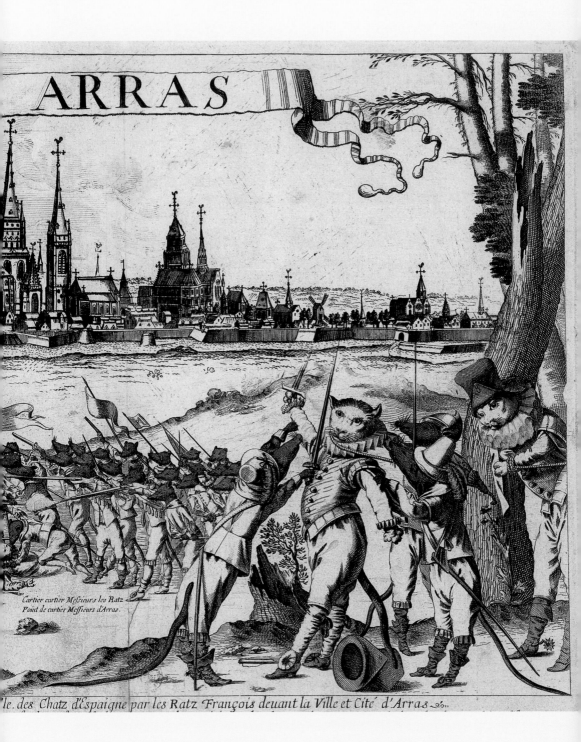

ARRAS

Cartier cartier Messieurs les Ratz
Point de cartier Messieurs d'Arras.

le des Chatz d'Espaigne par les Ratz François deuant la Ville et Cité d'Arras

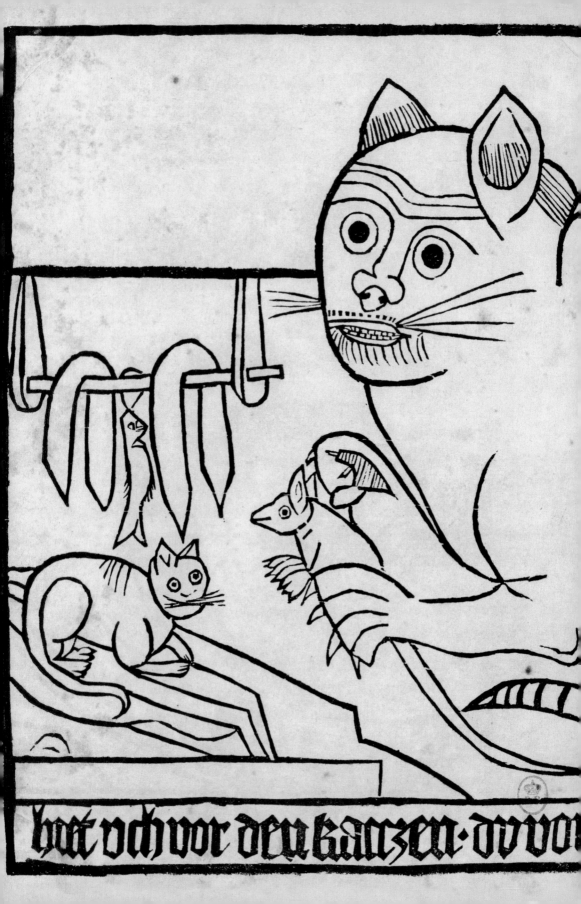

hůt dich vor den katzen · du vol

lecken vnde hinden kraczen

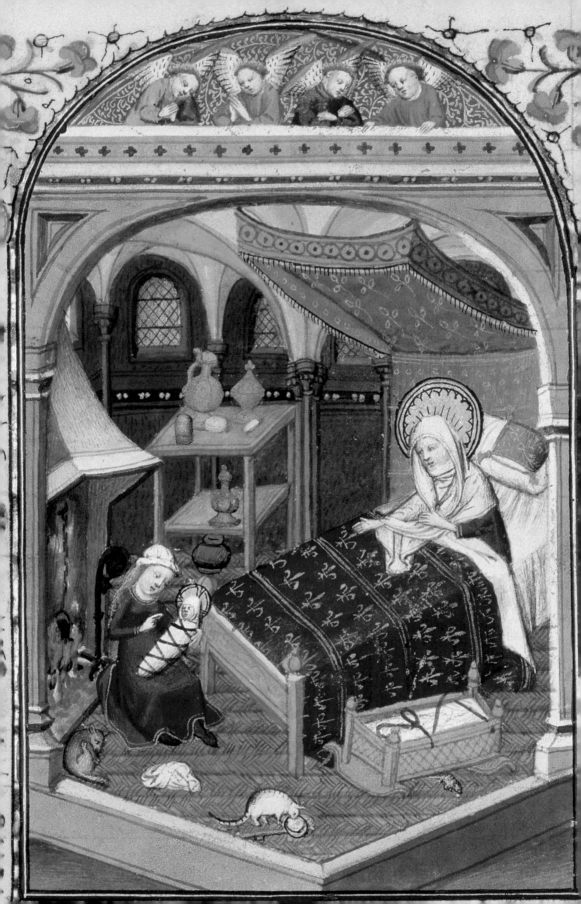

But it was its hunting skills that brought the cat into European homes, through the service entrance as it were, since it progressed from the attics to the storeroom, and thence to the kitchen, the living-room and even the bedrooms.

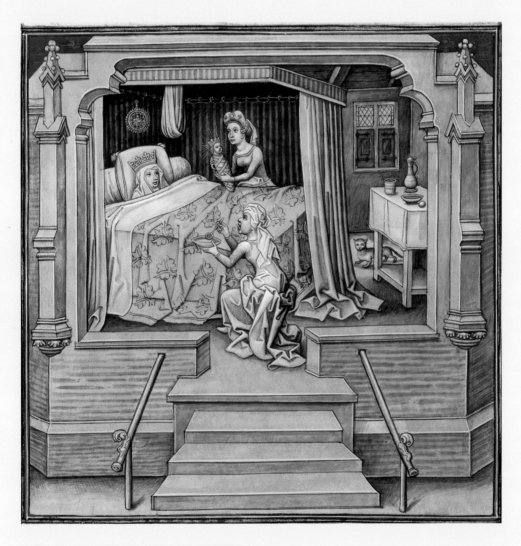

39

As we have seen, the cat represented the devil in religious iconography. Yet sometimes, in pictures of the Virgin Mary, Christ, or a saint, a cat nursing her kittens was merely an image of motherliness. Rembrandt's 1654 engraving of *The Holy Family with a Cat* shows Mary in a humble interior with a cat lying beside her. A snake is sliding out from a fold in her skirts, showing that the Virgin Mary had atoned for Eve's sin, while the cat clawing at her gown is the traditional personification of the Devil. At the same time it is a calm, familiar scene, often found in profane Dutch paintings and prints in the seventeenth century. The cat asleep by the fire or pilfering food in the kitchen is indeed a common iconographic theme. Pierre de Ronsard, who invented the adjective "miauleux" (caterwauling) wrote an ode called "The Cat" (*Selected Poems*) (1578). After saying: "There is not a man in the world who hates Cats as much as I do, with a deep-seated hatred," he added two lines, "having a horror of those people who cannot bear not to have a Cat living beside them", which seem to suggest that cat-lovers were already legion at the time.

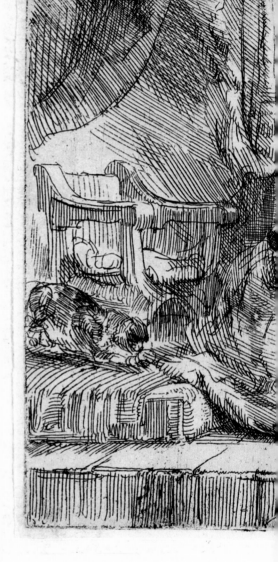

❧ "The Holy Family with a Cat", Rembrandt van Rijn (1606–69), etching, 1654
Estampes et Photographie, Réserve CB-13 (B 63)

40

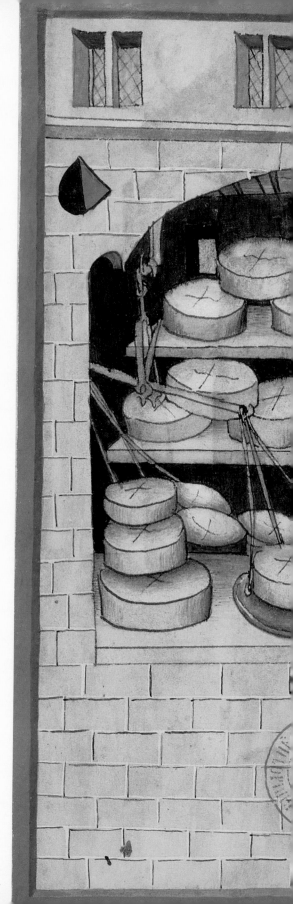

❧ "Cheese merchant talking to a customer, with a white cat in the background", miniature in *Tacuinum sanitatis*, illuminated manuscript, Rhineland, 15th century
An anonymous translation of *Taqwin al-sihha* by the Iraqi Ibn-Butlan (11th century), this health manual, with a special focus on diet, was a huge success in medieval Europe.
Manuscrits, Latin 9333, fol. 58v

One hundred and twenty years later, the library of the palace of the White Cat,
the heroine of Madame d'Aulnoy's *New Tales, or the Fancy of the Fairies*, was
hung with paintings telling "the history of the most famous cats: Rodilardus
hung by the heels in the Council of Rats, Puss in Boots, Marquis of Carabas,
the Writing Cat, the Cat that became a Woman, Witches in the Shape of Cats,
their Sabbat and all its ceremonies…" So the humble and much maligned tom-
cat seems to have infiltrated the Sun King's hall of fame. Contemporary engrav-
ings, particularly those by Abraham Bosse, show him comfortably settled in
bourgeois or noble houses, warming himself by the fire, or sitting placidly on a
chair with his paws tucked beneath him.

His hour had come: a travelling scholar from Aix-en-Provence, Nicolas-Claude
Fabri de Peiresc (1580–1637), brought angora cats back from Ankara in
Turkey. They were very popular (see pp. 58–59) as pampered pets, no longer
vulgar mouse-catchers relegated to the outhouses. About the same time, the
Persian cats that the Roman Pietro Della Valle (1586-1652) brought back from
his travels in the Middle East quickly became the darlings of great ladies. Yet
European cats still had their supporters, such as the academician-to-be Vincent
Voiture who, in c. 1630, thanked an abbess he knew for sending him a cat:

The greatest Beau-Cat of Spain is but a dirty Puss compar'd to him
and Rominagrobis himself, who you know, Madame, is Prince of the
Cats, has no better a Meine, nor can better smell out his Interest.
The Works of the Celebrated Monsieur Voiture (trans. John Ozell,
1731, p. 292).

The dirty Puss – "singed cats" in French – is an allusion to the horrible custom
of throwing cats on midwinter bonfires, which endured until the end of the
Enlightenment. The most famous cat-fancier of his time was Cardinal Richelieu.
Colbert's fondness for cats is less well known but was just as strong. The poet-
ess Antoinette Deshoulières, an eminent figure in the Sun King's court, had a
real mania for cats. She wrote countless verses about Grisette's amorous adven-
tures with well-born toms. Her daughter shared her enthusiasm for cats, and
wrote a tragedy in verse for highly affected pussies. In 1671, the renowned
harpist Mademoiselle Dupuy left a sum of money in her will for the care of her
cat (see p. 48). The *Mercure galant* of July 1678 embroidered on the story and
Bayle referred to the affair in his *Dictionnaire* in 1720.

CONCORDIA.

Diliges
dominum
Deum tuum
ex toto
corde tuo,
et in tota
anima tua,

Diliges
proximum
tuum
sicut
teipsum.
Deut. 6. a
Matth. 2.

M. de Vos figurauit

Melius est vocari ad olera cum charitate
Quam ad Vitulum saginatum cum odio.
Prouerb. 15. a. 17.

En paix auons contentement
En Noises tout desbauchement

PAX ALIT INGENIA, ET PRÆCLARAS EXCITAT ARTES, PAX HOMINI L

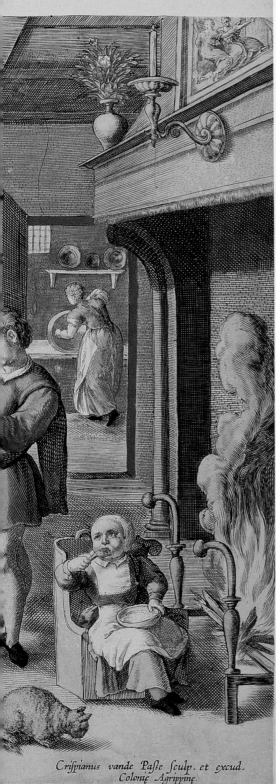

Crispianus vande Paße sculp. et excud.
Coloniæ Agrippinæ.

eßer ein weinig ist mit lieb .
an viel auß· häß vnd mit betrub

DAT BONA CVNCTA MANV.

❧ "Merchant's shop in Lille", Christian Van de Past from Cornelius De Vos, illuminated copper-plate engraving in *Histoire sacrée de la Bible* by Jan Mes, ca. 1590
Réserve des livres rares, RES A-1403 t. 11, fol. 136

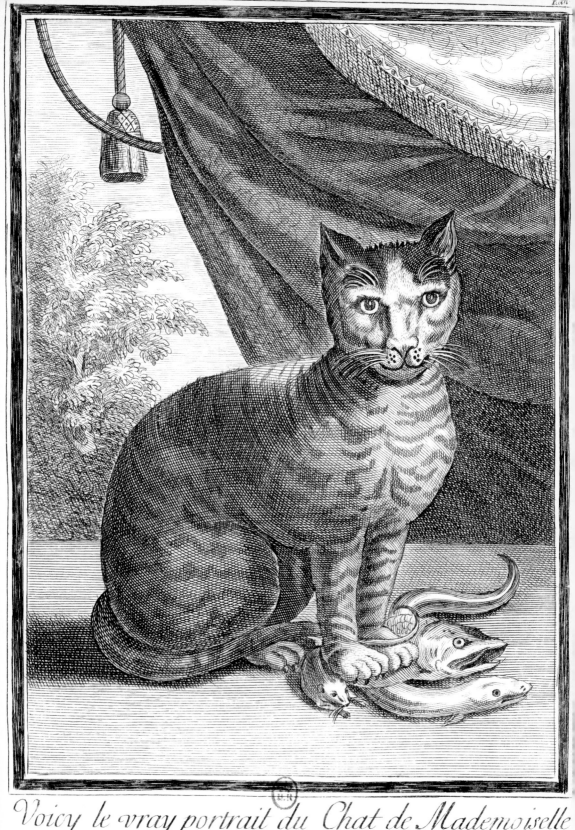

Voicy le vray portrait du Chat de Mademoiselle
Dupuy qui lui a laissé par Testam.ᵗ 15.ˢ par mois.

A Paris chez F. Guerard vis a vis la Fontaine S.ᵗ Severin a l'Image N.D.

In 1727 François-Augustin Paradis de Moncrif, a familiar at the court of the Duchess of Maine at Sceaux, royal censor, reader to Queen Marie Leczynska and royal historiographer, used the story of Mademoiselle Dupuy's will and the works of Antoinette Deshoulières and her daughter in the book which brought him glory: *Cats* (trans. Reginald Bretnor, Golden Cockerel Press, 1961), published "with the approbation and privilege of the King".

Moncrif was admitted to the Académie Française in 1733. The following year a parody of his speech was published "by Puss at the Kit-Cat Club" with the title *The Meow or Very Learned and Most Sublime Harangue Meowed by Lord Raminagrobis, on the 29 December 1733* [...]*, of which he is suspected of being the author. Abbé Guyot Desfontaines responded in 1731 with the anonymous publication at Ratopolis of a *Letter from a Sanctimonious Rat to Citron Barbet, on the Subject of the History of Cats. By Mr de Montgrif*. There was money to be made. In 1737 Claude-Guillaume Bourdon de Sigrais published an ambitious *History of Rats, to Contribute to Universal History*, also at Ratopolis. Despite sarcastic remarks – Voltaire called him the royal "historiscratcher" – Moncrif's great work was republished in 1738, 1741, 1748, 1767 and 1787 in *Œuvres badines* by the Comte de Caylus, who had Coypel's drawings engraved for the

CHAT NOIR PREMIER NE EN 1725.

Sçachant a qui je plais Connois ce que je vaux.

✿ "Here is the true portrait of the cat of Miss Dupuy, who left him 15 *livres* a month in her will", Charles-Antoine Coypel (1694–1752), engraving for *Les Chats* by François-Augustin Paradis de Moncrif
Estampes et Photographie, TF-4 PET FOL, t. 1, fol. 86

❀ "Black cat first, born in 1725. Knowing whom I please. I know what I am worth", Charles-Antoine Coypel (1694–1752), engraving for *Les Chats* by François-Augustin Paradis de Moncrif
Estampes et Photographie, TF-4 PET FOL, t. 1, fol. 78

first edition. The Bibliothèque de l'Arsenal has a fine copy of the book, with a superb binding stamped with the coat-of-arms of the Duchess of Maine, a cat fancier herself because Moncrif tells us that she wrote an epitaph for her beloved Marlamain. Cats such as Louis XV's white angora were indulged at Versailles, too. Pampering the pets of fashionable ladies quickly became a must for the *petits maîtres* of the time.

The Republic of Letters was not immune to the craze for cats. James Boswell made no secret of Dr Johnson's fondness for cats in general and for Hodge in particular. A print by Charles-Nicolas Cochin the Younger showed the French and European public "Madame Du Deffand's angola [sic] cats" sitting regally on an armchair. The marquise, whose salon attracted the elite of the Enlightenment, even had her book-bindings ornamented with brasses representing a seated cat. She sent a copy of the *Life of Clement XIV** decorated in this way to her friend, the English writer Horace Walpole, another cat-fancier, with whom she kept up a correspondence for fifteen years (until her death at the age of eighty-three).

❖ "Mrs Deshoulières' Tom and his Lady... a Rooftop Opera: Anthropomorphic Scene", Charles-Antoine Coypel (1694–1752), engraving for *Les Chats* by François-Augustin Paradis de Moncrif
Estampes et Photographie TF-4 PET FOL, t. 1, fol. 80

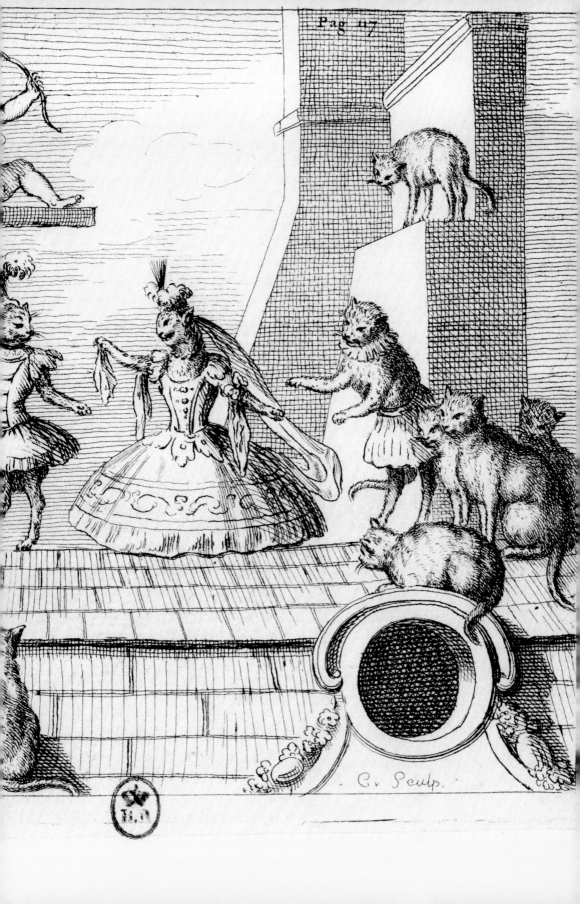

C. Sculp.

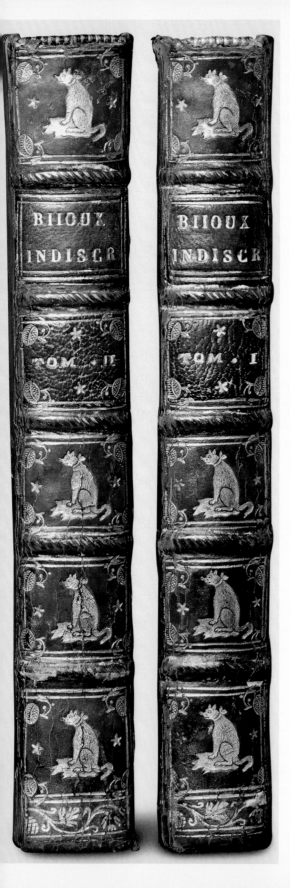

This copy, now at Strawberry Hill, Walpole's neo-Gothic mansion, was reproduced in Christabel Aberconway's *Dictionary of Cat Lovers* (1949). The letters between the marquise and her dear Horace Walpole are peppered with allusions to cats. "I don't know if one can make what one likes of a Frenchman," wrote Walpole in June 1774, "but I do know that one can change a cat's nature as easily as that of an Englishman. Rest assured, that you will never make a cat into a dog. Ask Buffon." "Your comparison between the English and cats is exact," replied the marquise, "except that cats do not boast of being cats; I do not need M. de Buffon to learn of their character and discover that they have claws. I know how different they are from little dogs…" Another muse of the late Enlightenment and hostess to the Idéologues, the widow of the philosopher Helvetius lived in the midst of some twenty angora cats.

But cats had enemies, too. In Book IV of his *Natural History* (see pp. 19, 54-55, 58) published in 1753 (trans. William Smellie, 1780, p. 77) Buffon was critical: "The cat is an unfaithful

❧ Denis Diderot (1713–84), *Les Bijoux indiscrets*, Au Monomotapa, undated, 2 vols. in-12
Calf binding adorned with a cat on the panel on the spine, from the library of the Marquise Du Deffand.
Réserve des livres rares, Smith Lesoüef 1679 and 1680

domestic, and kept only from the necessity we find of opposing him to other domestics still more incommodious". As a Cartesian, Buffon believed that "a domestic animal is a slave destined to the amusement, or to aid the operations of men. The abuses to which he is too frequently subjected, joined to the unnatural mode of his living, induce great alterations both in his manners and dispositions," because "Man holds a legitimate domination over the brute animals, which no revolution can destroy. It is a domination of mind over matter." The sensualist philosopher Condillac, in *Treatise on Animals** (1755), defended the animals' sensibility without going so far as to quote Moncrif, who had rather provocatively written: "We would do well to look for education in the gutters," thereby raising the cat to the rank of a model of civility. Before he became a famous economist, Jean-Baptiste Say was the editor of *Décade philosophique et littéraire*, the Idéo-logues' review during the Revolution. In 1794 the young Say published a brief account of disagreeable experiences at the house of friends who owned two female cats "and offspring in proportion". The cats mewed to have their share of the meal, and clawed their way on to the visitors' laps: "Complaints were out of the question: they were the spoilt children of the house; they got away with every-thing." But Say was also an anglophile and England in the eighteenth century was already pussycat land. He took a kinder, more nuanced view, not devoid of humour, in the collection of aphorisms that he published on his return from Eng-land, entitled *A Little Book of Musings on Man and Society** (1817):

> I do not know who said that people who love cats are also distin-
> guished by their philanthropy. At first glance, one would be tempted
> to take that for a joke, but several examples confirm this remark,
> so there must be some truth in it [...] Buffon accuses the cat of "lik-
> ing its comfort, and looking for the softest chairs to lie and frolic
> on", just like men; of "caring for caresses only for the pleasure they
> give him", like men again; or of "being the enemy of all con-
> straints", just as men are. So it follows that one must have a good
> dose of philanthropy to love cats.

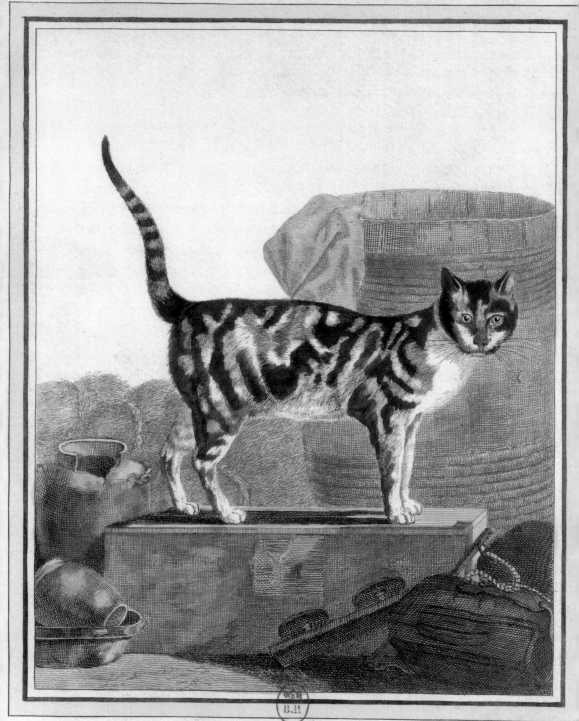

LE CHAT D'ESPAGNE.

♣ "Tortoiseshell Cat", Louis Legrand, engraving
from a drawing by Jacques de Sève (1742–88)
for Buffon's (1707–88) *L'Histoire naturelle (Les
Quadrupèdes)*, 1749–67, Paris, Imprimerie Royale

Estampes et Photographie, JB-24 4° t. 1

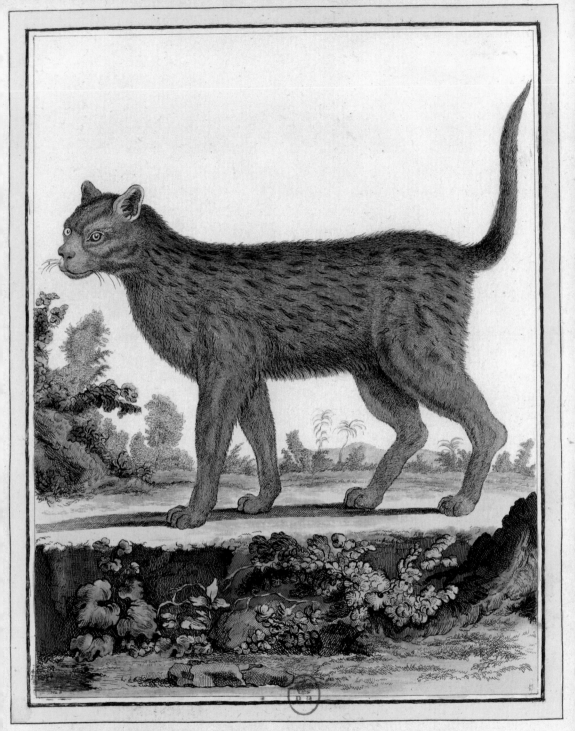

290. LE CHAT SAUVAGE DE LA NOUVELLE ESPAGNE.

♣ "Wild Cat of Viceroyalty of New Spain", Louis Legrand, engraving from a drawing by Jacques de Sève (1742–88) for Buffon's (1707–88) *L'Histoire naturelle (Les Quadrupèdes)*, 1749–67, Paris, Imprimerie Royale

Estampes et Photographie, JB-24 4° t. 1

About the same time, Chateaubriand wrote to the comte de Marcellus: "Buffon has mistreated the cat and I am working to rehabilitate it. I hope to make it an animal of breeding, in the style of the times." He came a little late: the cat was already triumphantly installed in the best of houses. More than that, the love of cats, which went far beyond merely tolerating kitty in the kitchen, spread through all social classes. Daumier's engravings show childless lower-middle-class couples flanked by a cat and a dog, the cat usually on the woman's side. And every concierge had her cat, which played its part in keeping the house in order by catching mice by night and keeping its mistress company in the poky lodge by day. In 1828 Dr Alexandre Martin Saint-Ange published, under the penname of "Catherine Bernard, porteress", a *Complete Treatise on the Physical and Moral Education of Cats, Followed by the Art of Curing its Ills**. The same year, the versatile freemason Jean M.-M Rédarès published a *Treatise on the Education of the Domestic Cat... by M. Rattie, former canon**, which was republished in 1835. The Romantics' favourite illustrator, Grandville,

signed an article entitled "Physiognomy of the Cat"* in *Le Magasin pittoresque*, along with twenty drawings illustrating various feline expressions: he had counted seventy-five (see p. 61). In 1845 the first book on the cat's anatomy was published in two volumes with an atlas of engravings: *The Anatomy of the Cat*. Its author, the Alsatian Hercule-Eugène-Grégoire Strauss-Durkheim, had to publish it at his own expense, but was soon rewarded by a prize of fifty thousand francs granted by Louis-Philippe. It was a surprising, informative work, and Jules Husson, called Champfleury, the leader of the realist school and a friend of Baudelaire, Théophile Gautier and Nadar, referred to it in the preface to his own work on cats. *The Cat, Past and Present,* Champfleury's book, a mix of erudition and amusing anecdotes, with fifty-two illustrations, was published in French in 1869 (translated in 1885) and was an instant success; two new editions were brought out before the end of the year. Viollet-le-Duc, Mérimée, and the Egyptologist Albert-Émile Prisse d'Avesnes provided information and drawings for the chapters on the history of the cat in Antiquity and the Middle Ages.

Like Moncrif before him, Champfleury had a store of ammunition to defend cats against their enemies. One notorious cat-hater was the Fourierist Alphonse Toussenel, who was fond of hunting and loathed Englishmen and Jews. Champfleury mustered a long line of cat-lovers from Muhammad to Baudelaire, without forgetting Richelieu and Moncrif, and illustrated his book with prints from Delacroix, Manet, and Hokusai. Japan was then in vogue and joined Egypt, already mentioned by Moncrif but now better known, as a country that was particularly partial to cats. Although he does not acknowledge it, Champfleury probably read *Cats: Excerpts of Rare and Curious Works in Verse and Prose, Anecdotes, Songs, Proverbs, Superstitions, Lawsuits, etc.; Iconographic and Bibliographic Notes, All About the Feline Race**, published by Jean Gay in 1866, "In Paris, by the author and in Brussels by Jules Gay". The author, who was born in 1838, was the son of Jules Gay, a publisher and bibliographer in Brussels, but he was a nobody in literary circles so his book went unnoticed. And yet Gay had taken a scholarly approach, consulting Ravenel, the curator of the Bibliothèque Impériale, and the famous bibliophile Jacob, alias Paul Lacroix, the curator of the Bibliothèque de l'Arsenal. After Champfleury, books on cats became more common: works were published by Marius Vachon, in 1896, Paul Mégnin, in 1899 and Madame Jules Michelet, posthumously in 1904 with an introduction and notes by Gabriel Monod, the historian's pupil and successor. Champfleury's work had forestalled its publication nearly forty years earlier.

Agricultural and pet shows flourished in the nineteenth century, originating in England as one might expect. The first cat show was organised by Harrison Weir in London's Crystal Palace in 1871. The same Harrison Weir founded the National Cat Club in 1887. The first Paris cat show was held in 1896 at the initiative of the journalist Fernand Xau. Others followed. Two notorious cat-fanciers, the writer Pierre Loti and the painter Théophile Steinlen, presided over the Bordeaux cat show in 1905. In 1908 Loti was elected chairman of a cat protection society, La Patte de velours (Velvet Paw). In 1926 three Sacred Cats

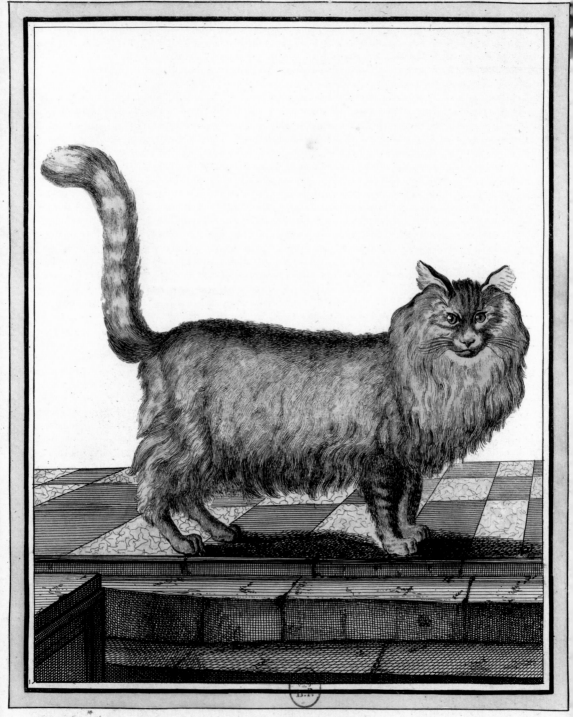

·100· LE CHAT D'ANGORA.

❖ "Angora Cat", Louis Legrand, engraving from a drawing by Jacques de Sève (1742–88) for Buffon's (1707–88) *L'Histoire naturelle (Les Quadrupèdes)*, 1749–67, Paris, Imprimerie Royale
Estampes et Photographie, JB-24 4° t. 1

❖ "Buy my little dogs, my fine angola [sic]", engraving by Poisson, *Cris de Paris dessinés d'après nature*, plate 67, 1774
Estampes et Photographie, Oa 133A t. 4

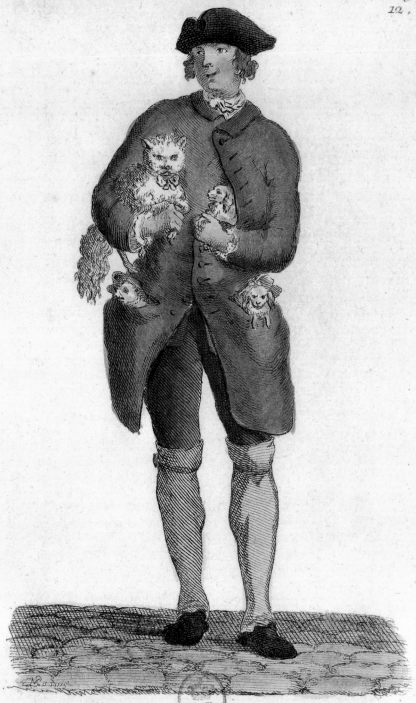

DOUZIEME CAHIER DES CRIS DE PARIS,
Dessinés d'après nature par M.ʳ Poisson.

Achetez mes petits Chiens mon bel Angola.

A Paris chez l'Auteur Cloitre S.ᵗ Honoré maison de la maitrise au fond du jar: din.

of Burma caused a sensation in Paris at the first international show organised by the Cat Club de France et de Belgique, which was founded in 1913. Cross-breeding became increasingly frequent, so that in the twentieth century the number of breeds rose from sixteen to about forty.

In the early twenty-first century, cat-worshippers seem to have the upper hand, at least in rich countries. Magazines, television shows, film, musicals, and websites are devoted to their idols. And the cat has attained the enviable status of consumer in the capitalist world. Like its devoted human servants, it now hunts only for sport.

❖ "Seated Cat", J.-J. Grandville (1803–47), one of twenty ink and wash drawings for "Physionomie du chat", in *Magasin pittoresque,* January 1840
Estampes et Photographie, Réserve B-6B FOL, t. 2, fol. 36 no. 32

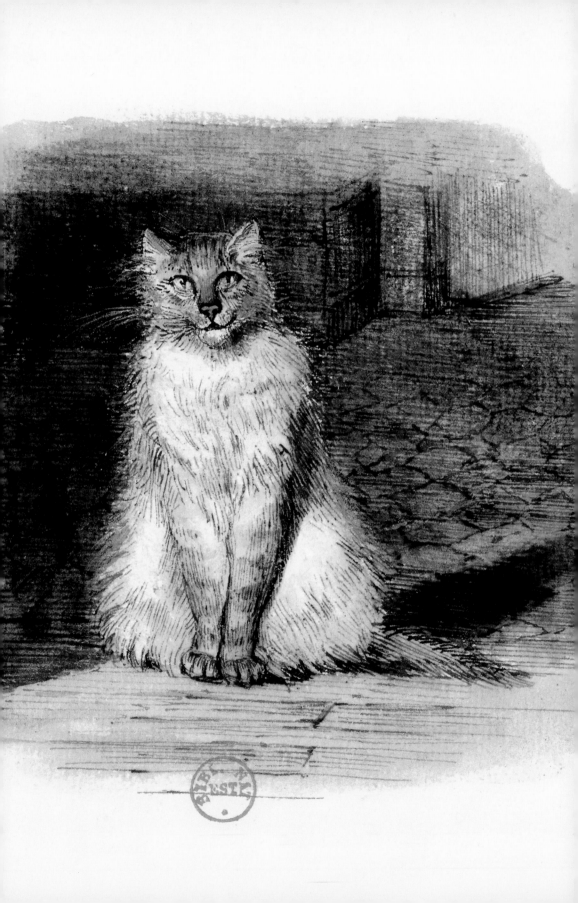

" Puss went into a corn-field, drew off his boots, in order to approach the birds without noise, spread open his sack to serve as a net, and, fastening a string to the end of it, lay down behind the hedge. He waited a long while in vain; but at last the partridges came, and, attracted by some crumbs within the bag, hopped in one after the other: at that moment Puss drew the string and, whipping the sack, birds and all, over his shoulder, marched off to the palace. [...] Puss made a low bow, and emptied his bag at the king's feet, at the same time turning away his head, lest the birds should provoke his appetite, and said, 'My master, the Marquis of Carabas begs your majesty's acceptance of some game, which he has just taken.' The king's mouth watered at the sight, and regaining his good humour, he enquired after the marquis, said he must make his personal acquaintance, asked why he never came to court, and, sending for the Chancellor of the Exchequer, desired him to give Puss as much money as he could carry. "

Charles Perrault, "Puss in Boots",
Histories or Tales of Past Times, Told by Mother Goose
(trans. New York, Leavitt & Allen, 1859)

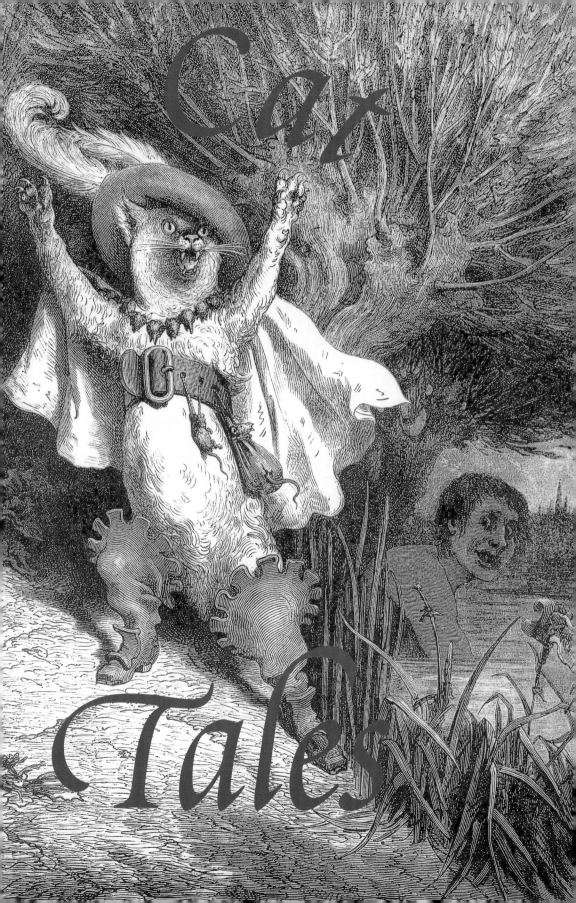

te deus in eternum. Dates nr̄.

ne nos. Iube domine benedice.

Alma virto intimum intere

y nob, ad dominum. R̄. ỹma

Siuvtte beatissima u

tto maria miserabi

diter attum pro nobis si

ttere et impletttre ma

redimptorie. Ni preces

nobis quos cernis offe

sos, ante oculos condito

tu autem domine mis

ar mi. Deo gratie. Antip

Beata es virgo maria dei ge

mativ que credidisti domino

fetta sunt in te que dicta su

tibi exultatu es super choroe

❧❧ "Help! Help! The Marquis de Carabas is drowning", Adolphe-François Pannemaker (1822–1900), woodcut after Gustave Doré (1832–83) for "Puss in Boots", *Contes* by Charles Perrault, Paris, J. Hetzel, 1862
Estampes et Photographie, DC-298 (J) FOL, t. 11

*L*aurence Bobis writes that, from the thirteenth century, "the cat often appears in the bestiary of proverbs, fables, nonsense poetry, riddles, tales and stories, and in *soties* [short satirical plays] and farces, all literary genres testifying to passages and exchanges between popular and erudite cultures" (*The Cat. History and Legends** [2000], p. 164). Even now the cat is the hero of many proverbs, often associated with a fool or a child who tries to teach it to read or to play music, or wraps it up like a baby, or hangs a bell around its neck to stop it from hunting, and is likely to be tricked or scratched. Cats figure in collections of prints from the Middle Ages to the seventeenth century, as in Jacques Lagniet's set of etchings published in 1663 in which we find another allusion to the siege of Arras in 1640: "This Spaniard devoured by rats is a strange sight to see, but what gnaws and galls him most is the memory of losing Arras" (see p. 67 and pp. 34-35).

(see p. 67 and pp. 34-35).

65

❧ "A fool (betrayed by his hood) tries to teach a cat to read", margin illumination in *Heures à l'usage de Paris*, illuminated manuscript, late 16th century
Manuscrits, Latin 1393, fol. 31v, detail

❧ "As comfortable as a cat in a well", illustrated proverb in *Livre d'heures à l'usage de Rouen*, illuminated manuscript, Rouen, late 15th century
Manuscrits, NAL 3134, fol. 80

urbatus est a furore
oculus meus inueteraui inter
omnes inimicos meos

Iscedite a me omnes
qui operamini iniquitatem
qm exaudiuit dns uocem
fletus mei

rauiduit dns depreca
tionem meam dominus
orationem meam suscepit

rubescant et conturbe
tur vehementer omnes inimici
mei conuitantur et erube
scant valde velociter Ba

eati quorum remisse
sunt iniquitates

aussi arse que dict that
qui Reuisse Cybrich prius

♣ "Cats and kittens chase rats and little rats.
Rats know much, but cats more still.
At night, all cats are grey", Jacques Lagniet (1600?–1675), *Recueil des plus illustres proverbes*, Paris, 1663
Estampes et Photographie, Réserve TF-7-4, pl. 85

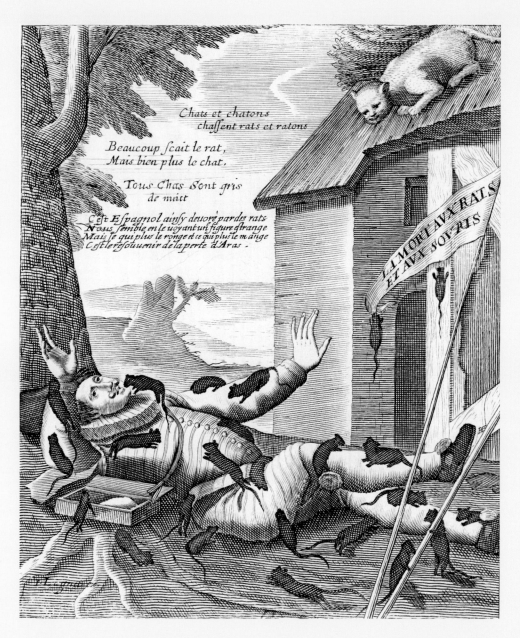

67

♣♣ "That's life", Jacob Matham (1571–1631), engraving from Adrian van de Venne, *Recueil de pièces facétieuses et bouffonnes de 1500 à 1630*, 17th century

The topsy-turvy world when old enemies, the cat and the dog, dance together, while rats frisk under their feet.
Estampes et Photographie, Réserve TF-1, p. 57

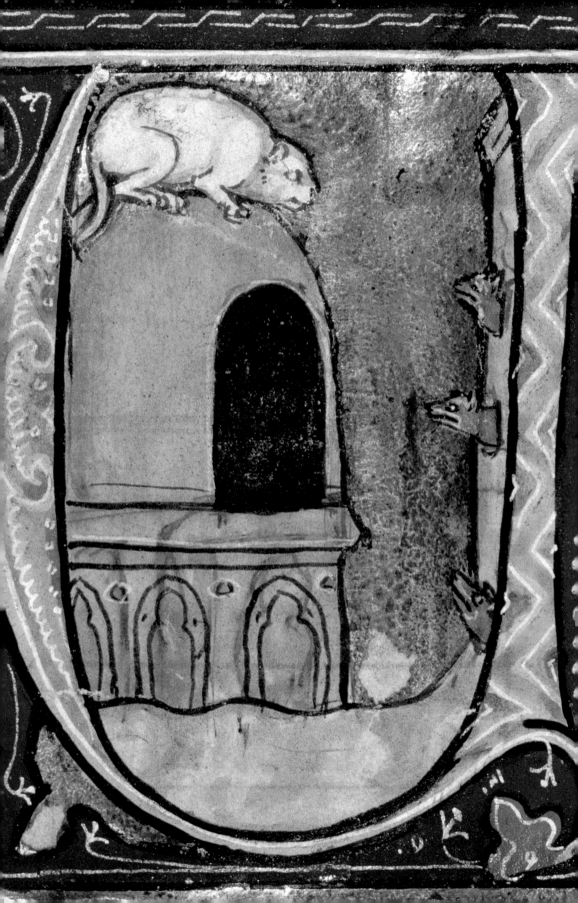

*T*he collections of fables published from the early Middle Ages were called *ysopets* because they took their inspiration from the works of the Greek fabulist Aesop and from his Latin successor Phaedrus too. The latter is known through adaptations, because his *Fables* were not published until 1596, not long after his manuscripts were discovered by François Pithou. La Fontaine drew heavily on the *ysopets*. The most famous of these collections was composed in the thirteenth century by the poetess Marie de France; it includes the fable of "The Fox and the Cat" and "The Cat that became a Bishop". Aesop's influence can also be seen in *Reynard the Fox*, a series of stories by several authors in the twelfth and thirteenth centuries – adapted by Maurice Genevoix in 1934 – in which the cat Tibert rivals in craftiness with Reynard the Fox.

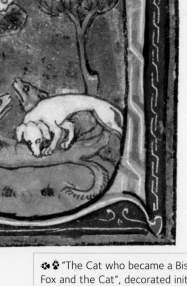

❖ ❖ "The Cat who became a Bishop", and "The Fox and the Cat", decorated initials by Jean de Papeleu for Marie de France's *Fables*, ca. 1295
Arsenal, MS 3142, fols. 272v and 272, details

Carlo Collodi drew on the same theme in his universally loved *Pinocchio* (1881), in which we find the cat and the fox, two sly, malicious characters, who first trick the hero and then hang him. The other source for fables is the *Book of Kalîla and Dimna* which inspired La Fontaine to write "The Cat, the Weasel and the Young Rabbit", and "The Cat and the Rat". *Kalîla and Dimna* is believed to be a translation of the fables of Bidpai, taken from one of the great epics of Indian civilisation, the *Pantchatantra*. They are thought to have been written in Sanskrit about AD 200, then translated into Persian and lastly adapted in Arabic about 750 by Ibn al-Muqaffa', a high dignitary known for his writings on political and personal ethics. The heroes, jackals Kalîla and Dimna, tell stories and lay down the rules for good conduct. This collection of fables, probably part of a princely education, was a huge success with the cultivated elite and was translated into many languages – Persian, Turkish, Mongol, and Latin. The sometimes illuminated copies brought back by travellers enriched

the great European libraries. Sir Thomas North translated it into Elizabethan English as *The Fables of Bidpai: The Morall Philosophie of Doni* (reprinted by Joseph Jacobs, 1888).

72

♣ "The Cat, the Rabbit and the Weasel", Émile-Florentin Daumont, etching from a painting by Alexandre-Gabriel Descamps (1803–60), 1888
Estampes et Photographie, DC-199 A, t. 3

♣ "The Nightingale, the Hare, and the Cat", miniature in *Le Livre de Kalîla et Dimna*, translated by Nasr-ollâh Monchi, illuminated manuscript, Iran, Shiraz, ca. 1390
Manuscrits, Persan 377, fol. 87

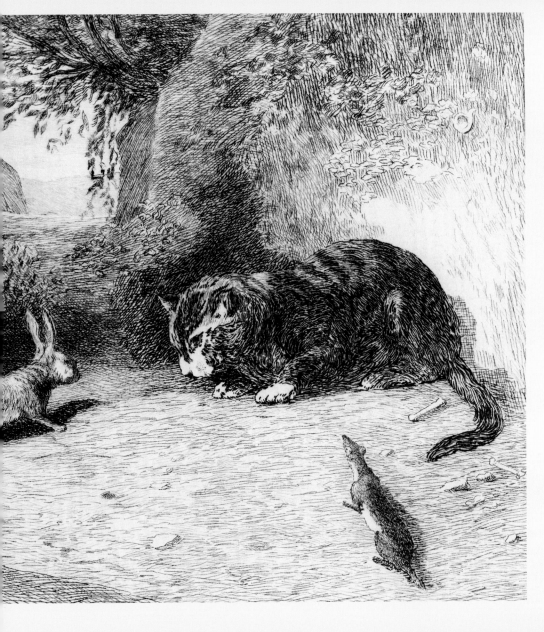

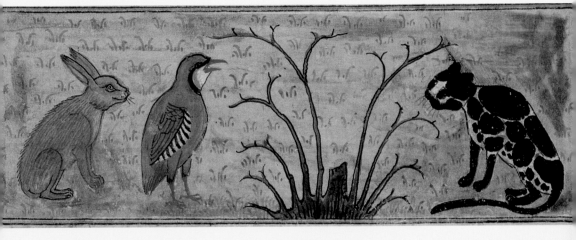

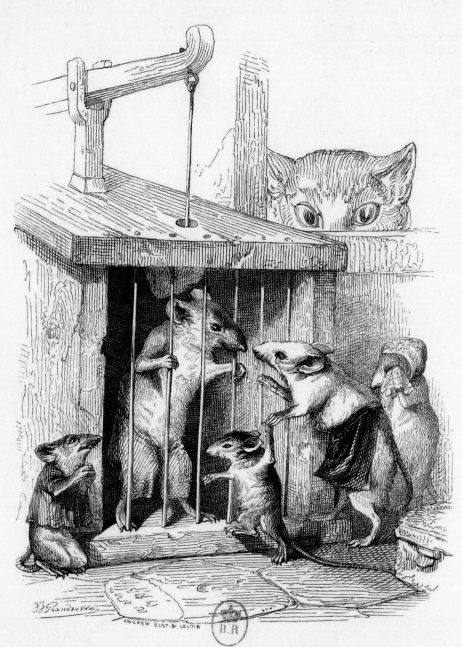

Il nous dit : Ne pleurez pas, agissez ! peut-être à quelques pas d'ici, l'ennemi veille dans l'ombre

"'Don't weep, do something!... Perhaps, not far from here, an enemy is lurking in the shadows... Try to escape him... More than once I have watched with interest the construction of these traps invented by the perversity of man; and if I am not mistaken, there is a way out. This door which has just closed behind me is attached to what science calls a lever.' My father was an avid reader; he knew a little about everything."

♣ "The Philosophical Rat", J.-J. Grandville (1803–47), engraving for a text by Édouard Lemoine, in *Scènes de la vie privée et publique des animaux*, P.-J. Stahl ed., Paris, 1841

Estampes et Photographie, DC-199 (D), FOL, t. 6, engraving 53, p. 61

♣ "The Cat and the Rat", miniature in *Le Livre de Kalîla et Dimna*, translated by Nasr-ollâh Monchi, illustrated manuscript, Baghdad or Tabrîz, ca. 1380
Manuscrits, Persan 376, fol. 172

At an interval of over two thousand years, Aesop and La Fontaine drew an unflattering portrait of the cat: the Greek, eight times and the French fabulist, sixteen. La Fontaine called the cat the "Attila of the rats" or better, the "Alexander of cats", but it hunted with craft, cruelty and trickery ("The Cat, the Weasel and the Young Rabbit") and denied its friends in its own interests ("The Cat and the Two Sparrows"). Its nicknames reveal the author's contempt: Raminagrobis, Ratto, Rodilard, Grab-and-Snatch, or Clapperclaw, somewhat reminiscent of Rabelais' scathing term for the magistrates: "Chats Fourrez" (Furry Fat Cats). In 1792, Jean-Pierre Claris de Florian published fables with the heavy moral overtones of the late Enlightenment. The cats that figure in ten of these fables show that life had improved for them in the eighteenth century.

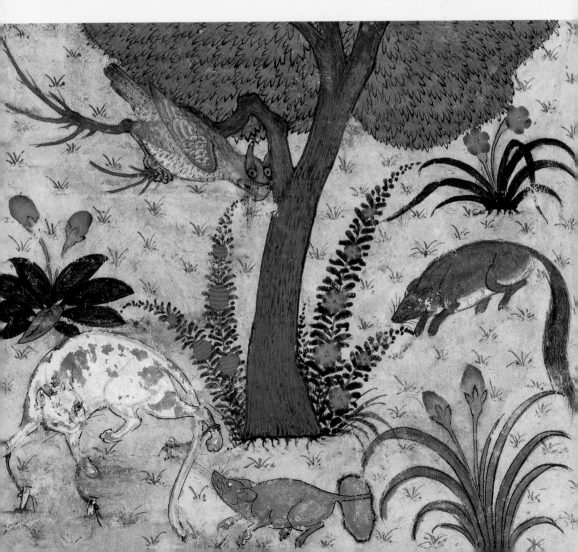

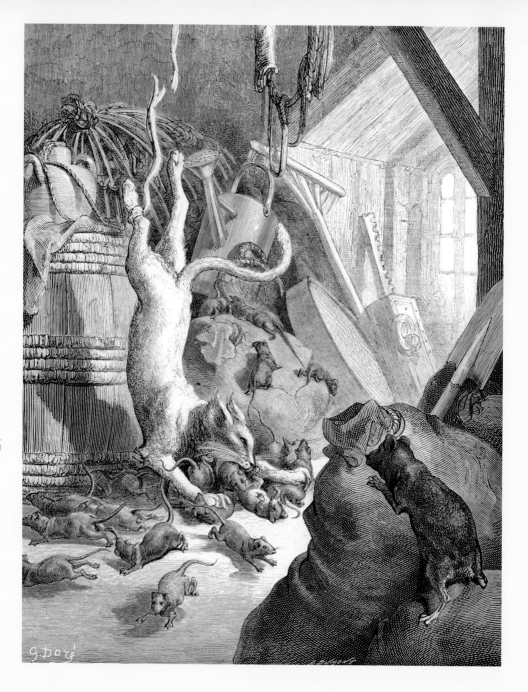

76

❧ "The Cat and the Old Rat", Dumont, engraving from Gustave Doré (1832–83) for La Fontaine's *Fables*, Paris, 1868

Estampes et Photographie, DC-298 (I), FOL

❧ "The Nightingale, the Hare, and the Cat", miniature in *Le Livre de Kalîla et Dimna*, translated by Nasr-ollâh Monchi, illustrated manuscript, Baghdad or Tabrîz, ca. 1380

Manuscrits, Persan 376, fol. 146

"The Inquisitive Cat" opens with this interpellation:

> Ye bold philosophers, who strain
> Th'inexplicable to explain,
> Deign but to listen while I tell
> What once a curious cat befell.

After trying in vain to catch its reflection, the cat "left the glass and went for mice". The fable ends with a precociously positivist condemnation of metaphysics:

> "For what," thought she, "can be the use
> Pursuing matters so abstruse?"

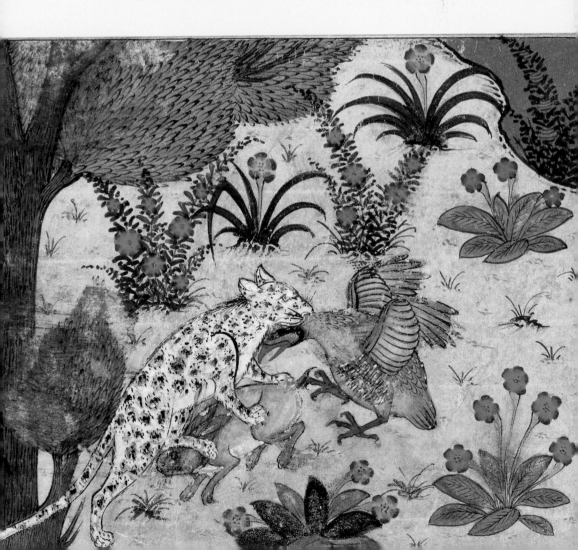

Involv'd in snares without an end
Which none can ever comprehend.
Let wise philosophers discuss
What has no use for them or us.

"The Two Cats" tells the tale of two brothers "of ancient pedigree" who descend from the famous Rodilard. One hunts and the other does not. But it is the idle cat, "round and portly, fresh and sleek", who counsels his brother. Behind the vapid moral "The real secret of success, / In cunning lies, not usefulness", the conclusion gives a glimpse of the future of lap-cats:

> But I,
> Can always near my master sit,
> And seek to please him by my wit.
> I share his favours, his repast;
> Ask little first, take much at last;
> Strive to amuse him with my tricks,
> Learn'd in the school of politics
> (trans. Gen. J. W. Phelps, New York, John B. Aldkin, 1888)

The cat in the fables is usually hypocritical and cruel, but sometimes cuts a positive, even moral figure. Unlike the horse and the dog, reserved for the nobles, the cat is the companion of the peasant, the sailor, and the merchant. Humble as it may be, the cat helps his master succeed. In the legend of the foundation of Venice, told by Albert de Stadt in the twelfth century, a merchant grows rich through the hunting skills of his two cats. In England, the story of Dick Whittington, "thrice Lord Mayor of London", is a variation of the same theme. A play was made of the life of Richard Whittington (1354–1423) as early as 1605, but it is the pantomime *Dick Whittington and his Cat*, first performed in the early nineteenth century, which made the popularity of this merchant from the minor nobility, who became Lord Mayor of London, a Member of Parliament,

❧❧ "The Council of Rats", engraving for *Choix de fables de La Fontaine, illustrées par un groupe des meilleurs artistes de Tokio sous la direction de P. Barbouteau*, Tokyo, 1894
Réserve des livres rares, RES P-YE-225

lent the king money, and founded charitable institutions. In fact, the real Whittington was never poor, and we do not know much about his legendary feline friend who made his fortune by killing the rats on his merchant ship (such ships were called "cats" at the time). The legend may originate in the Persian tale of an orphan who grew rich because of his cat. There is a similar tale in the "Novella delle gatte" printed in Arlotto's *Facetiae* in 1483. Another descendent of this line, *Le Chat botté* (a.k.a. Puss-in-Boots) soon reached international fame. Already in *Piacevoli notti (The Facetious Nights)* by Giovanni Francesco Straparola (published 1550–56), the tale came to Charles Perrault's ears through oral traditions. A talking cat, inherited by the third son of a miller, helps his master by countless ruses to marry a princess. In exchange, the cat's life is spared. This deal was accepted by the young man because:

> [...] he had often seen him play a great many cunning tricks to catch
> rats and mice, such as hanging by his heels, or hiding himself in the
> meal, and pretending to be dead; so he did take some hope that he
> might give him some help in his miserable condition.

Published in the *Histories or Tales of Past Times, Told by Mother Goose* in 1697, this tale has survived the years and spread far and wide, inspiring many artists such as Grandville and Gustave Doré. Jacob Grimm included it in his *Tales*, and Ludwig Tieck brought it to stage. Puss in Boots dances in the third act of Tchaikovsky's *Sleeping Beauty* and plays in *Shrek* speaking fluent English and signing his name "P" with a flourish of his sword – hence the "Chat Potté" of the French version. As a sign of the times, this twenty-first-century cat's great strength is not catching mice, but melting his foes with a beseeching look.

In "The White Cat" by Marie-Catherine d'Aulnoy, published in *Contes nouveaux ou les Fées à la mode* (1698), the cat is once more an enchanting protector and guide. The Comtesse de Ségur took her inspiration from Madame d'Aulnoy for "*Forest of Lilacs*" (*New Fairy Tales*, 1857) in which Prince Perfect, by the irony of fate, is turned into a cat.

❖❖ "A Cat of a Rare Kind", engraving for *Gran teatro infantil. 169. Biblioteca moral y recreativa para los niños*, theatre book after *Le Chat botté*, Paris, Déjardin, 1884
Estampes et Photographie, KH–Mat 8A (Jeux livres animés) (1)

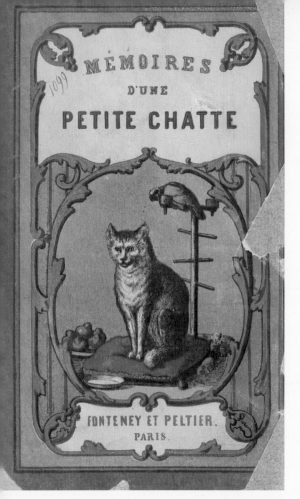

Many fairy-tales were originally written for adults. Little by little, the cat became a star in the growing stream of children's literature which developed from the eighteenth century, until it even furnished the title of the series of seventeen *Contes* published by Marcel Aymé between 1934 and 1946 (*The Wonderful Farm,* 1951). The cat made its first appearance on children's bookshelves in England in the Keepsakes, small picture-books given as New Year gifts. It travelled to France in the second half of the century: the *Memoirs of a Little Cat** by Madame Chevalier-Desormeaux were published in 1863, with a pretty cardboard cover showing the heroine sitting on a cushion. The same year, Hachette's "Bibliothèque rose illustrée" included *Chien et chat ou Mémoires de Capitaine et Minette* translated from the English *Dog and Cat, or Memoirs of Captain and Puss* and illustrated by forty-five vignettes; the work had been published by Berger-Levrault the year before, under a different title. In 1864 came *Toupee and Carnage. Memoirs of a Cat Scribbled by Himself** by Eugène Nyon, republished by the City of Paris in 1880 for distribution as a school prize. *The Neptune's Cat** (1886) published by Victor Hugo's friend Ernest d'Hervilly regaled adults as well as children with the (mis)fortunes of Tom, a cat fished out of the sea by Lieutenant Coquillard. All these texts are highly conventional. More fanciful tales about cats began with Lewis Carroll: the Cheshire Cat in *Alice in Wonderland* (1865) vanishes leaving a disconcerting grin hovering in the air. Hardly surprisingly, this very British tom appealed to the Surrealists. It popped up again in the early twenty-first century in *Lost in a Good Book* by the

♣ ❖ Madame O. Chevalier-Desormeaux, *Mémoires d'une petite chatte*, Paris, Fontenay et Peltier, 1862, cover and frontispiece
Littérature et Art, Y2-26918

"He sometimes had fun without realising it by putting paper hats on my head"

Il s'amusait quelquefois à son insu, à me mettre
des bonnets en papier. Fr.

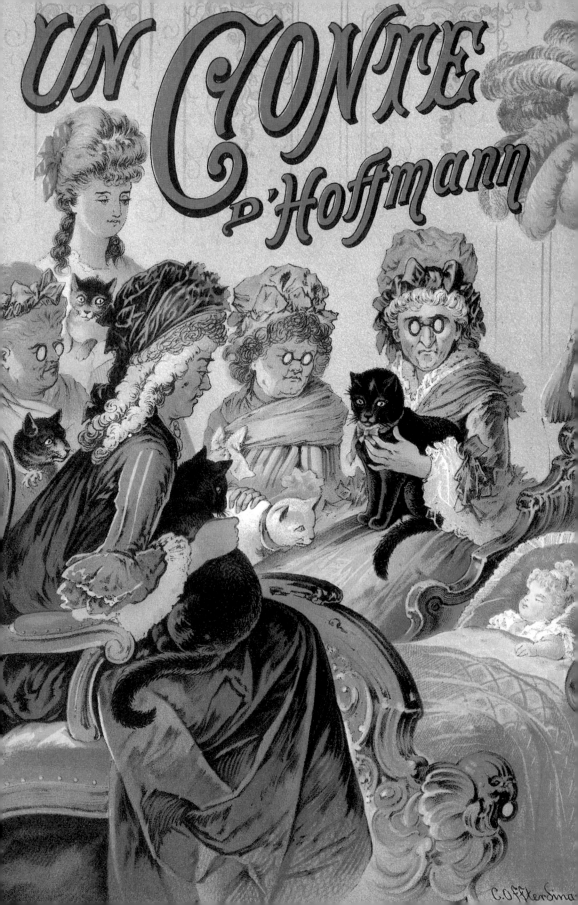

Carl Offlerdinger (1829–89), cover illustration for E. T. A. Hoffmann's (1776–1822), *Un conte d'Hoffmann, histoire du prince Casse-Noisette et du Roi des souris*, Paris, Jouvet, 1883
Littérature et Art, 4-Y2 PIECE-122

cat is initiated into the lore of the London streets by the indomitable Jennie.

Cats have flourished in the work of illustrators, too, such as Beatrix Potter, Nathalie Parain (see p. 113) Benjamin Rabier (see p. 172). The cat has a great role to play in comic-strips and cartoons opposite his longstanding rival, the dog, and old enemy, the mouse. And the *Aristocats* (1970), with its cult song "Everybody wants to be a cat", was the last animated feature launched by Walt Disney before his death in 1966.

Welsh writer Jasper Fforde, the brilliant inventor of the paradox of time-travel applied to textual genetics. Here the Cheshire cat is the curator of a strange, desirable "Great Library", which stocks not only all the books ever written, but all those to come and even those that will never be published.

Cat stories for children, particularly in English, are far too numerous to be listed here. We might just mention *Rroû* by Maurice Genevoix (1931) and the delightful *Jennie*, published by American writer Paul Gallico in 1950, in which a small boy turned into a stray

Beatrix Potter (1866–1943), *The Story of Miss Moppet*, London, Frederick Warne, 2002, pp. 24–25
Littérature et Art, 2002-152236

Puss in books is probably best loved by toddlers. As Champfleury pointed out in *The Cat, Past and Present*:

> The important part played by the cat in the impressions of early childhood is easily explained by its presence in even the poorest household, its marked outline, constantly before the children's eyes, and its one and only utterance, which is easy to imitate and retain in the memory. We might fill a volume with nursery rhymes about cats.
> (trans. Frances Cashel Hoey, London, G. Bell and Sons, 1885, p. 23)

"In nursery rhymes, the cat is always first," observed the Scottish writer Compton Mackenzie in *Cats' Company* (1960). "Pussy cat, Pussy cat", which first appeared in 1805 in *Songs for the Nursery*, is an all-time favourite with English children. In the nineteenth century, ABCs and picture-books made extensive use of the little feline, whose name lends itself to a play on words in most languages. Edward Lear, an ornithologist, draughtsman and poet of the absurd, who inspired Lewis Carroll, the precursor of the pataphysicians, juggled brilliantly with the theme. In 1867 he published *The Owl and the Pussy Cat*, a collection of illustrated limericks originally meant for his employer's children. Lear also wrote a delightful alphabet book enlivened by burlesque drawings of his cat Foss. The manuscript is in the Victoria and Albert Museum, London.

In a similarly bizarre vein, in 1932 Robert Desnos wrote *Tristan's Zoo** for the son of his friends, Lise and Paul Deharme. It was published by Gallimard in *Destinée arbitraire* in 1975, and includes "The Cat that Looks like Nothing on Earth"* illustrated by the poet himself. The manuscript is in the Bibliothèque Jacques Doucet.

❖ "C was a lovely Pussy Cat", Edward Lear (1812–88), *Victoria and Albert Museum. A Nonsense Alphabet*, London, H. M. Stationery Office, 1952
Estampes et Photographie, KB-290 (28)-4

In a more caustic register, the "Song for my cat Potasson" by Léon-Paul Fargue in *Les Ludions* (1930) uses the babyish language that small children and pets have to put up with and, in Juliette Raabe's view, goes beyond a joke to attain the sublime

Il saut' sur la fenêtre
Et groume du museau
Pasqu'il voit sur la crête
S'découper les oiseaux
Tirelo

He jumps up by the window
and whets his pretty lips, tirelo,
coz he sees on the rooftop
a birdie's silhouette,
tirelo
(trans. © 2001 Peter.Low@canterbury.ac.nz)

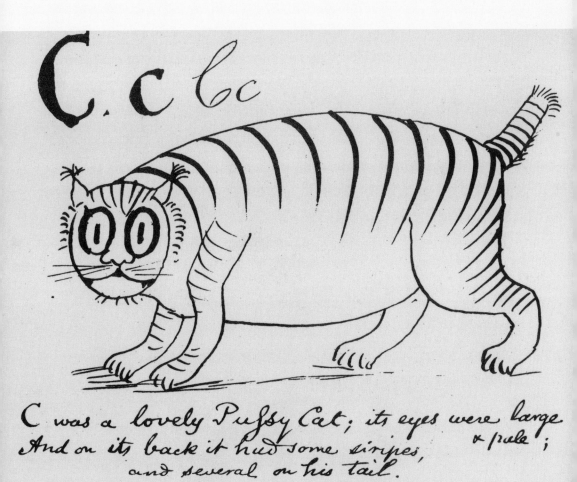

C. c bc

C was a lovely Pussy Cat; its eyes were large & pale;
And on its back it had some stripes,
and several on his tail.

❝ But the Baby cried because the Cat had gone away, and the Woman could not hush it, for it struggled and kicked and grew black in the face.

"O my Enemy and Wife of my Enemy and Mother of my Enemy," said the Cat, "take a strand of the wire that you are spinning and tie it to your spinning-whorl and drag it along the floor, and I will show you a magic that shall make your Baby laugh as loudly as he is now crying."

"I will do so," said the Woman, "because I am at my wits'end; but I will not thank you for it."

She tied the thread to the little clay spindle-whorl and drew it across the floor, and the Cat ran after it and patted it with paws and rolled head over heels, and tossed it backward over his shoulder and chased it between his hind-legs and pretended to lose it, and pounced down upon it again, till the Baby laughed as loudly as it had been crying, and scrambled after the Cat and frolicked all over the Cave till it grew tired and settled down to sleep with the Cat in his arms.

"Now", said the Cat, "I will sing the Baby a song that shall keep him asleep for an hour."

And he began to purr, loud and low, low and loud, till the Baby fell fast asleep. ❞

Rudyard Kipling, "The Cat that walked by himself", *Just So Stories*

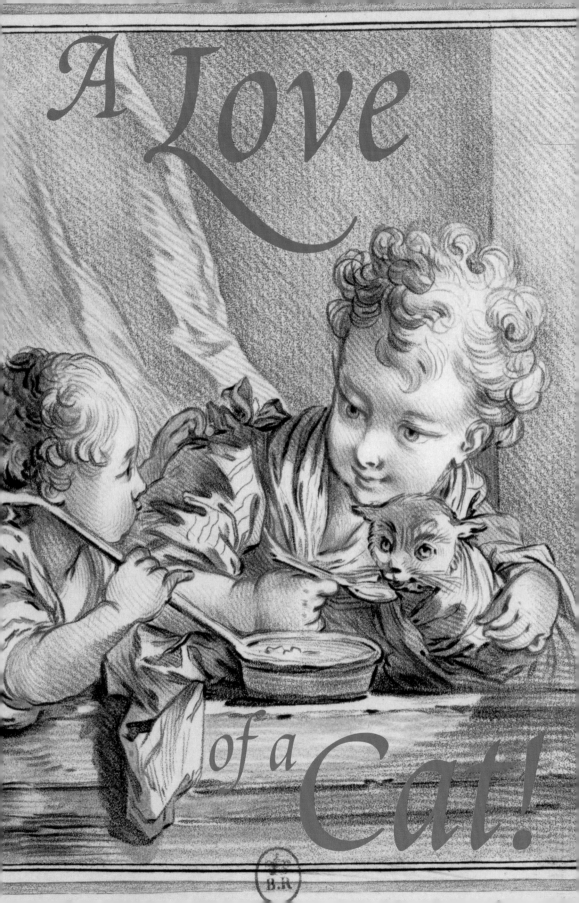

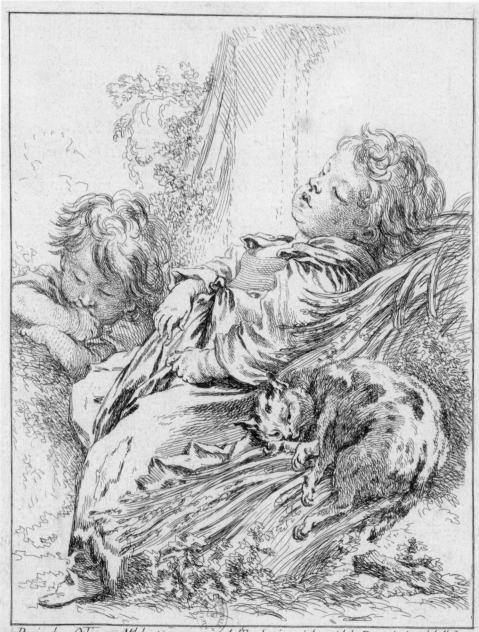

a Paris chez Odieuve M.d des tampes quay de l'Ecole vis avis le coté de la Samaritaine a la belle Image.

92

♣♣ "The Darling Cat", crayon-manner engraving by Gilles Demarteau (1729–76), after a drawing by François Boucher (1703–70)
Estampes et Photographie, Réserve EF-9 FOL, t. 16, p. 36, no. 545

♣ "Two Children and a Cat Asleep", François Boucher (1703–70), etching
Estampes et Photographie, DB-28, FOL. t. 1

In the *Très Riches Heures du duc de Berry*, illuminated by the Limbourg brothers about 1415 and now in the Musée Condé, Chantilly, the month of January shows the duke banqueting with his hunting dogs and pets. For February, the artists chose a rustic interior where a white cat huddles by a wretched hearth with his masters. The cat was long the animal of the peasant, the villein. It was only much later that it appeared in noble or bourgeois interiors. One of the earliest representations of children playing with a cat was *The Artist and his Family,* painted in 1584 by Otto van Veen (1556–1629) and now in the Louvre. A handsome white cat in the foreground is being stroked by a tiny girl, who does not seem to fear being scratched. Such a scene is unusual. Even so, the names of all the figures except the cat are written in the cartouche. *Boy and Girl with a Cat* painted by Judith Leyster (1609–60), now in the National Gallery, London, is both an intimist genre scene and an allegory of folly, because the children foolishly ignore the cat's claws.

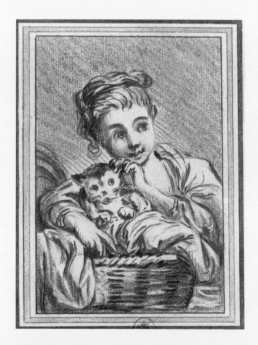

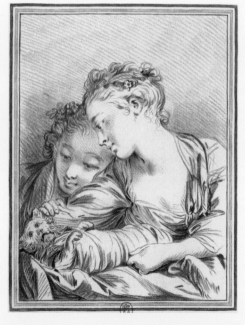

♣ "Girl with a Swaddled Cat", Gilles Demarteau (1729–76) crayon-manner engraving from a drawing by François Boucher (1703–70)
Estampes et Photographie, Réserve EF-9 FOL, t. 8, no. 198

♣ "The Swaddled Cat (Children's Games)", Gilles Demarteau (1729–76), crayon-manner engraving from a drawing by François Boucher (1703–70)
Estampes et Photographie, Réserve EF-9 FOL, t. 10, pl. 23

One of the favourite motifs of seventeenth-century Dutch paintings and prints is a cat bundled up like a baby, and sometimes being fed by adults or the older children. It belongs to the theme of a topsy-turvy world: people swaddled cats – by force – on Shrove Tuesday in memory of Joseph feeding the Infant Jesus. In the eighteenth century, the theme lost its religious and symbolic connotations and became a silly child's game in which the cat was not manhandled but coddled and fussed over. A series of crayon-manner engravings by Gilles Demarteau the Elder after François Boucher (see pages 91–93) shows children, little girls in particular, playing dolls with a more or less docile kitten, wrapping it up, mothering it and spoon-feeding it. One of these engravings is called "The Darling Cat". Jean-Honoré Fragonard also drew a swaddled cat, which was engraved in 1778 by his sixteen-year-old sister-in-law Marguerite Gérard. Victor Hugo took up the theme in *Les Misérables*, when the little Thénardier girls play dolls with a cat, while Cosette imitates them as best she can as she bundles up a sword.

94

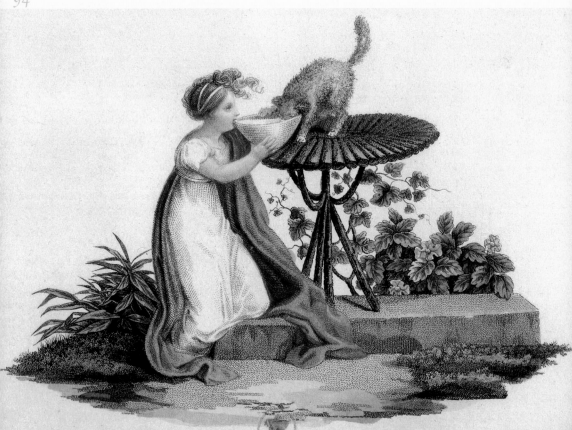

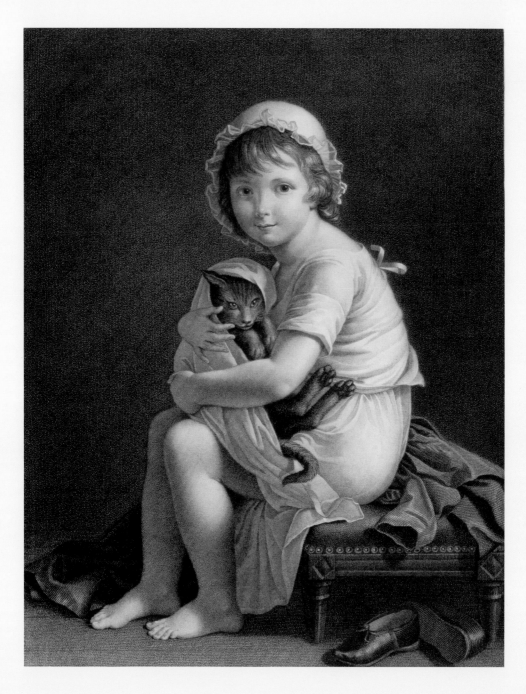

✿ "The Little Cats", no. 12, drawn and engraved by Madame Marchand, 1822

Estampes et Photographie, KH-448 FOL, t. 3

✿ "Evening. Girl and her Cat", Jean called John Godefroy (1771–1839), engraving from a painting by Elisabeth Chaudet (1767–1832)

Estampes et Photographie, EF-174 FOL

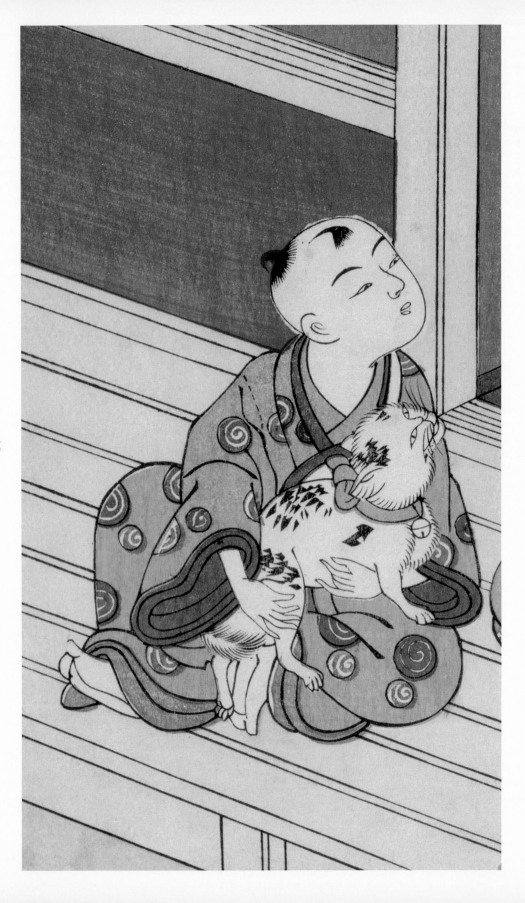

In *Steinlen Cats*, a story without words drawn by Théophile Steinlen, we see a very small girl, almost a baby, catch a black cat by the paw, forcibly bundle it up and, when scratched, go back to her doll. The child's unconscious cruelty is severely punished, and we sense the painter's sympathy for the cat. But the writer's sympathies are not always with the cat. Gustave Flaubert in *Bouvard and Pécuchet* and Jules Renard in *Poil de carotte* both told cruel tales of cats tormented by children. And the song about old Mother Michel who bewailed the loss of her cat, only to be told by Father Lustucru that it had been sold as a rabbit, is a children's classic.

Jean-Baptiste Perronneau (1715–83) was one of the first, about 1745, to put a pet cat in the foreground in his portraits of little girls. Others followed his lead: François-Hubert Drouais (1727–75) and Jean-Baptiste Greuze (1725–1805), who painted the son of the poet Baculard d'Arnaud, a child of five, holding a black cat in his arms in a painting now in Troyes museum. For the London and then Geneva editions of Jean-Jacques Rousseau's *Émile* (1777), Moreau the Younger drew a tender scene of family life with the caption "Why try to thwart the law of nature?" It shows two half-naked urchins fighting, the elder holding a white cat in his arms. Portraits of girls with cats were common from the nineteenth century, most famously painted by Louis-Léopold Boilly, Théodore Géricault, Auguste Renoir and Foujita (see p. 103). Steinlen drew endless portraits of his daughter and her many cats for advertising posters, unleashing a flood of postcards or calendars on the same theme (see pp. 104–109). In *Through the Looking Glass* published in 1872, Lewis Carroll described the games Alice played with the two kittens, one black and one white, of her cat, Dinah. Alice plays school with her kittens, scolding her naughty pupils. In Beatrix Potter's delightful *Tom Kitten,* the kittens are unruly little rascals that their very Victorian mother Tabitha tries in vain to dress as model children. Children the world over know Collodi's marvellous *Pinocchio* through Walt Disney's 1940 version of the tale, one of his best animation features. There are two cats in the film, the crafty Gedeon whom Disney anthropomorphised – he was not in the original illustrations – and Geppetto's cat, Figaro, whom Disney invented.

❖ "A Child holding a Cat", Harunobu Suzuki (1724?–1770), print
Estampes et Photographie, Réserve DE-12 Boîte FOL (2)
detail

Gedeon is the heir to very ancient tra-
ditions; Figaro on the contrary is a
playful, spoilt kitten such as today's
children might have at home or see in
a picture book. And Figaro is appar-
ently much more popular with young
audiences than Gedeon…

 "Terracotta cat", Aikawa Minwa (died 1821),
woodcut of toys, in *Tsûshin gafu*, 1834
Manuscrits, Japonais 4643, fol. 16v, detail

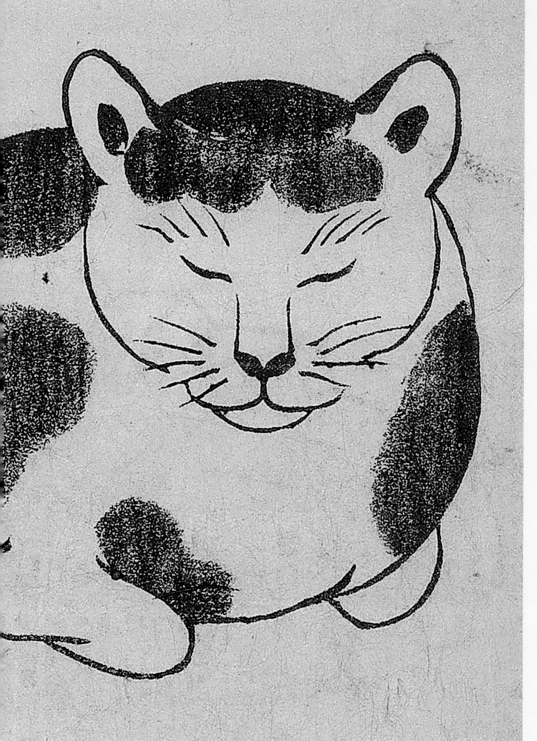

LES CHAGRINS DE L'ENFANCE.

Il est des peines pour chaque age : Mais à vingt ans, quelle douleur
A dix ans, c'est un grand malheur D'avoir pour amant un volage !
Qu'un oiseau sorti de sa cage ;

Dédiée et présentée à *Le Berger Sylvain.*

Madame la Duchesse *Son Altesse Sérénissime*

de Bourbon.

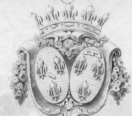

A Paris, chez l'Editeur, rue Saint Jacques. Par son très humble et très Obeisant Serviteur
N°. 55. Le Cœur.

Mouchet pinx. Le Cœur sculp.

Yet silliness does not suit the cat which, unlike small dogs, scratches, bites and above all remains a killer. A killer of mice, for which it is readily forgiven, and of birds which is less acceptable. In Goya's painting of *Don Manuel Osorio Manrique de Zuñiga* (1786), in the Metropolitan Museum, New York, the child is holding a string tied around a magpie's leg and behind him two evil-eyed cats are watching the unsuspecting bird. In 1791, Goya painted a similar portrait of *Don Luis Maria de Cistue*, in which the child has a small dog for company, but this painting is quite ordinary, with no sense of impending doom. The artist seems to have given the eerie presence of the cats the traditional meaning of evil lying in wait for innocence. The same moral undertones are found in William Hogarth's *The Graham Children,* 1742, a painting brimming with allegories of which the ferocious tabby cat stalking a caged goldfinch is not the least. The goldfinch was traditionally associated with Christ to symbolise the Passion and the immortality of the soul.

Conversely, the bird drawn by Mouchet and engraved by Louis Le Cœur has escaped the clutches of a handsome white angora, another pet that was hard to live with. No religious symbolism in this gracious image, no more than in the chapter "The cat and the bullfinch" in *The Misadventures of Sophie* (1859). Beau-Minon, the kitten found by Sophie and her cousin Paul, ends up devouring the tame bullfinch, a misdeed for which he is cruelly punished by Sophie's father, who inadvertently kills him in an attempt to save the bird. "Poor Beau-Minon," cries Sophie, "there you are dead and it is all your own fault." The cat in the stories of the implacable Comtesse de Ségur is indeed Buffon's animal which "readily learns society's habits, but never its manners".

101

❧ "The woes of childhood. Dedicated and presented to Her Highness Madame la Duchesse de Bourbon", Louis Le Cœur, coloured copperplate engraving from François-Nicolas Mouchet (1750–1814)
Estampes et Photographie, AA-3 (Mouchet)

"There is sorrow for each age:
At ten it is a great misfortune
If a canary flits its cage;
But at twenty it is torture
To have a flighty lover!"

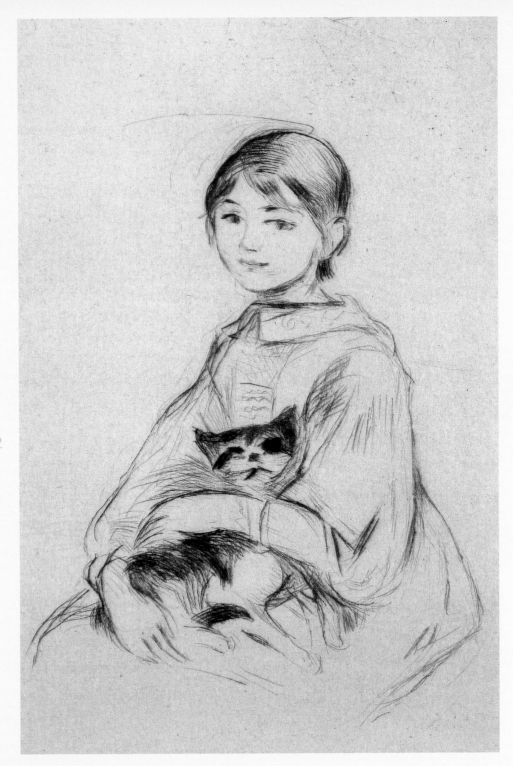

♣ "Julie Manet and her Cat", Berthe Morisot (1841–95), drawing, ca. 1889
Julie Manet was the only daughter of Berthe Morisot and Eugène Manet, the painter's brother.

This drawing is very close to Renoir's painting *Julie Manet ou l'enfant au chat*, in the Musée d'Orsay, Paris.
Estampes et Photographie, AA3-MORISOT (Berthe)

♣ "Girl with a Cat", Tsuguharu Foujita (1885–
1968), colour lithograph, 1959
Estampes et Photographie, DC-20 FOL

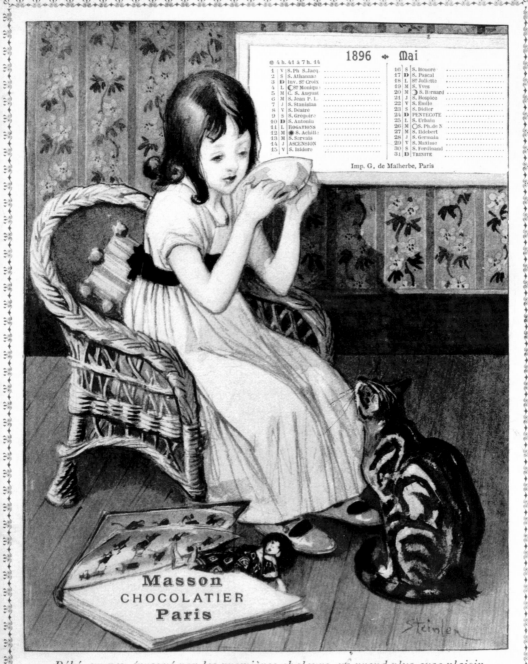

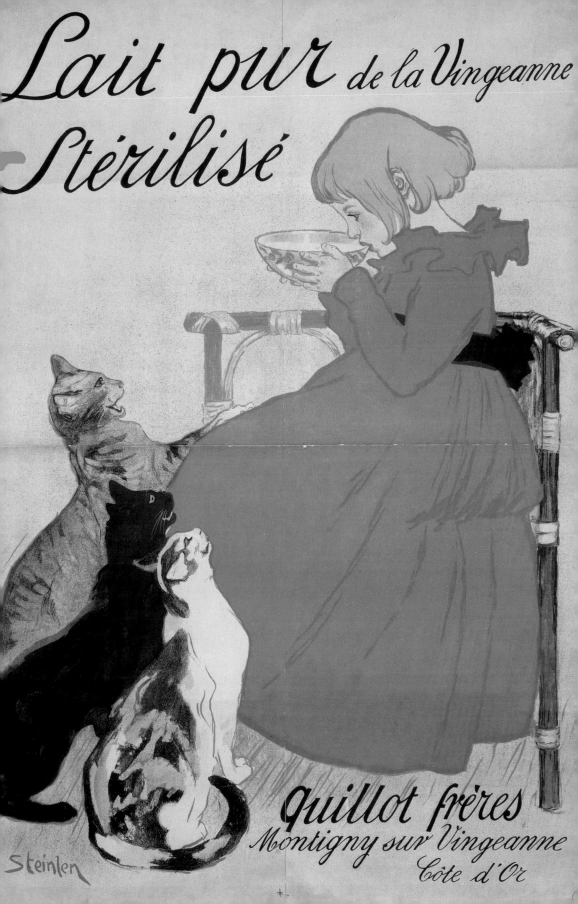

We know that Picasso chose the theme of the cat devouring a bird to illustrate fascist brutality in two paintings done shortly after the bombing of Guernica, while in Art Spiegelman's cartoon *Maus*, the Nazis are cats and the persecuted Jews are mice. The cat is the oppressor, the birds or the mice are the oppressed, and sympathy obviously goes to the victims. This sad theme is exploited in American cartoons figuring Tweety and Sylvester or Tom and Jerry, in which a hapless cat is systematically foiled by an ornery canary or a sassy mouse. One might deplore the fact that the cat, although by no means ferocious, comes over as a real idiot in these very popular cartoons. Without mentioning Azrael, the cat belonging to the sorcerer Gargamel in Peyo's *Smurfs*, who is a wretched leftover from the dark ages when cats were burnt along with their witches... One of the stories without words drawn by Steinlen in *Steinlen Cats* ends better: a disobedient little girl who goes off to play with the sparrows is gobbled up by an enormous black cat, leaving nothing but a heap of clothes and a few feathers. Balthus is famous for his paintings of girls in ambiguous poses, often with a cat. *Thérèse Dreaming* (1938) shows a girl of twelve or so, with her eyes closed and her arms folded behind her head, sitting on a *chaise longue*, with one knee drawn up to show her underwear. A cat is lapping a bowl of milk at her feet. At first glance, the painting resembles Marguerite Gérard's insipid *The Cat's Afternoon Tea,* which was so often reproduced or imitated). Yet it derives from the erotic prints of the eighteenth century. In this painting, as in may others by Balthus, the cat associated with the girl symbolises the desires that stir with adolescence and the loss of innocence.

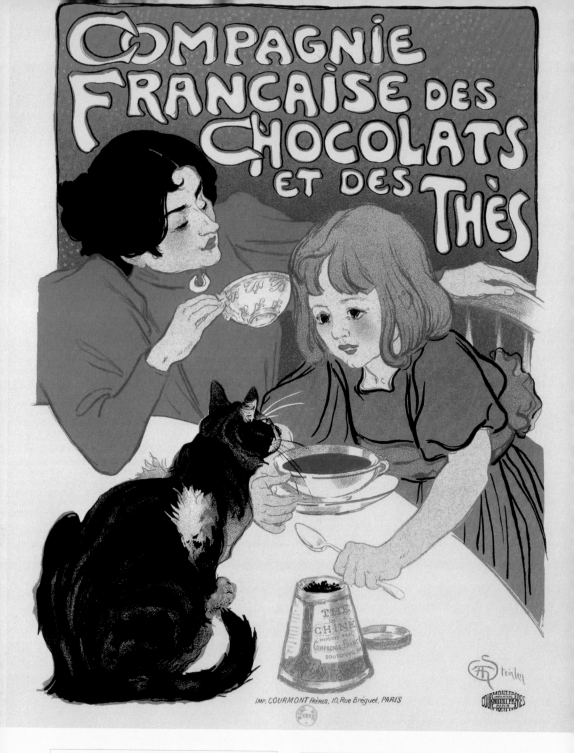

❧ "Compagnie française des chocolats et des thés", Théophile Steinlen (1859–1923), advertising poster, lithograph 1899
The preparatory drawing in the Louvre shows that the cat was a later addition.
Estampes et Photographie, DC-385 FOL t. 6

❧ "Des Chats. Dessins sans paroles", Théophile Steinlen (1859–1923), coloured lithograph for the cover of Des Chats published in 1898 by Ernest Flammarion.
The cats have multiplied in an almost terrifying way.
Estampes et Photographie, DC-385 FOL, t. 4

Dessins sans paroles

des Chats

par

Steinlen

PARIS
ERNEST FLAMMARION
EDITEUR
26 Rue Racine
Près L'Odéon

il n'est pas bon pour les animaux

Son petit chat Mistigri

en sait quelque chose !!!

Regardez dans quel état il met ses joujoux

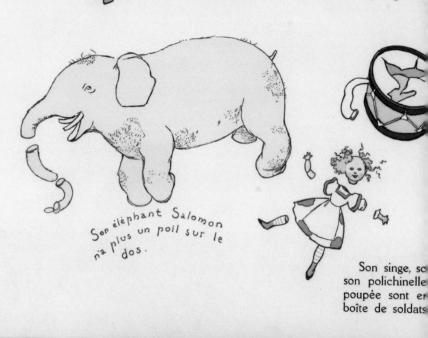

Son éléphant Salomon n'a plus un poil sur le dos.

Son singe, so
son polichinelle
poupée sont er
boîte de soldats

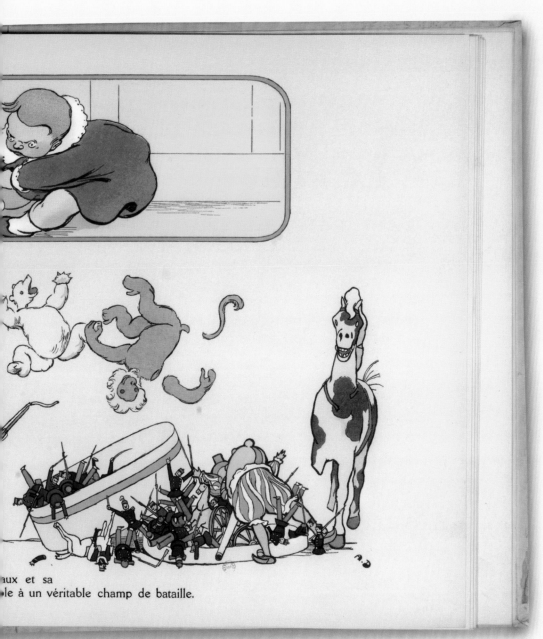

aux et sa
le à un véritable champ de bataille.

"He's not good to animals.
Fluff his grey kitten can tell you so!!!

The state of his toys is a tale of woe!

Solomon his elephant has a bald back,
His monkey's in pieces, his teddy's a wreck,
Punch and his doll have been frightfully mauled
And his box of lead soldiers is a real battlefield."

(Bad-tempered Augustus)

Le chat

Le chat est un animal qui a deux pattes de devant, deux pattes de derrière, deux pattes sur le côté droit, deux pattes sur le côté gauche.

Les pattes de devant lui servent à courir, les pattes de derrière lui servent de frein.

Le chat a une queue qui suit son corps. Elle s'arrête

au bout d'un moment.

Il a des poils sous le nez, aussi raides que des fils de fer. C'est pour ça qu'il est dans l'ordre des félins.

De temps en temps le chat a envie d'avoir des petits. Alors il en fait; c'est à ce moment qu'il devient chatte.

Cette rédaction scolaire d'un écolier de neuf ans a été imprimée par les soins de rm et de pab à 52 exemplaires avant les grandes vacances 1952

"The cat is an animal with two front legs, two back legs, two legs on the right side and two legs on the left side. The front legs are for running, the back legs work as brakes. The cat has a tail which follows his body. After a while it stops. It has stiff hairs under its nose, like lions' whiskers. That is why it is in the felion family. From time to time the cat wants to have kittens. So he does; that is when he becomes a mother cat."

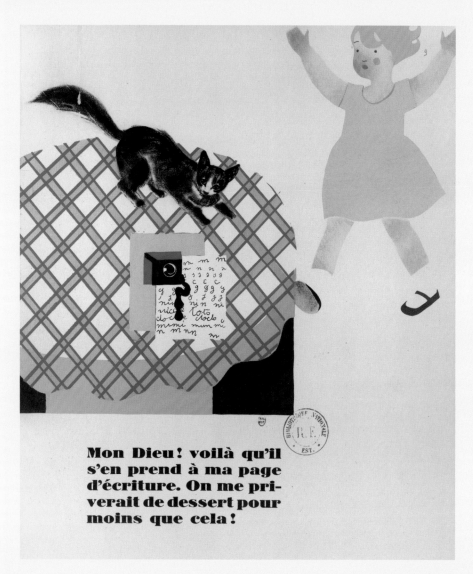

Mon Dieu! voilà qu'il s'en prend à ma page d'écriture. On me priverait de dessert pour moins que cela!

"Good god! Look how he attacks my page. I would be deprived of pudding for less than that!"

“ Sleep tight, black kitten
Sweet dreams, blue cat
No Oedipus complex
Need a puss perplex
He makes love to his mother
And they love one another
What a love, says his mother
My little black kitten
My own blond kitten
A true blue kitty cat. ”

Jacques Prévert, *Des Bêtes…*

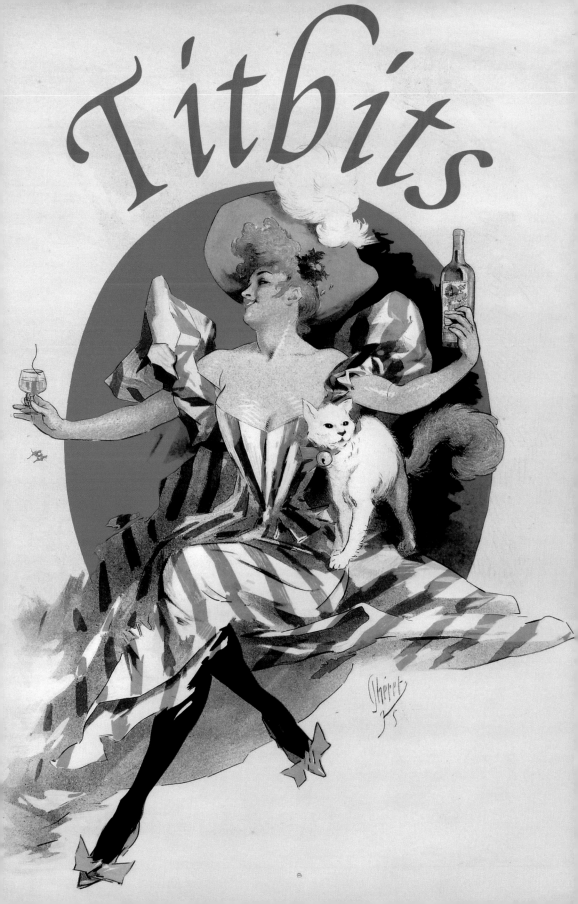

*T*he likeness between women and cats dates from time immemorial. The metamorphosis from cat to woman and back again is found in myths and tales all over the world. Ovid's *Metamorphoses* describe the transformation of the moon goddess Diana into a cat. In the Japanese vampire-cat story a cat falls in love with a young prince and turns into a woman. Aesop's fable of the cat metamorphosed into a woman and then into a cat again inspired a fable by La Fontaine, a vaudeville show by Eugène Scribe in 1827, an opéra comique by Jacques Offenbach in 1858, a pantomime played by the ever so feline Colette in a revue at the Ba-Ta-Clan in 1912 and, in 1927, a ballet by Henri Sauguet choreographed by Balanchine. Many illustrators have taken up the theme. The *incipit* of La Fontaine's fable "A bachelor caressed his cat, A darling, fair, and delicate" deserves to be as well known as his famous "Two doves once cherished for each other / The love that brother has for brother". It is marvellously apt for Colette's novel *La Chatte,* published in 1933.

In most civilisations, the cat is associated with the moon, whose cycles are in phase with women's menstrual cycles. Western iconography has associated the cat with Eve since the Middle Ages. A cat is crouched at her feet in Dürer's famous engraving. The art historian Erwin Panofsky put forward the idea that it symbolises choler, and that the other three animals personify the other humours in Hippocrates' theory – melancholy, phlegm, and blood. But we cannot fail to see that its tail curls around the woman's leg in symmetry with the snake rolled around a branch of the tree. In Pieter Saenredam's engraving after Abraham Blomaert, a cat is lying at Eve's feet, there too in the same diagonal as the snake, but this time shown with a peacock, probably symbolising pride. In *The Garden of Eden and the Fall of Man* by Peter Paul Rubens and Jan Brueghel the Elder, painted in 1615 and now in the Mauritshuis in The Hague, the cat is rubbing affectionately against Eve's leg as a sign of complicity. The daughters of Eve and the cat were later to suffer from their association, at least in the Christian West. In the East as in the West, the nights of the full moon belong to witches, who are often shown with a cat as a companion, a nocturnal creature par excellence. In Christian iconography, the cat as the incarnation of Satan was associated with heretics and

❧❧ "Quinquina Dubonnet. Apéritif, dans tous les cafés", Jules Chéret (1836–1932), advertising poster, printed by Chaix, Paris
Estampes et Photographie, DC-329 FOL, t. 4

❧ "Adam and Eve", Albrecht Dürer (1471–1528), line engraving, 1504
Estampes et Photographie, Réserve CA-4 (1) Boîte ECU

118

witches. Little by little it became the attribute of the witch alone, who symbolised a mix of heresy and sexuality. In Hans Baldung Grien's famous engraving, the cat is sitting back to back, or rather rump to rump, with one of the two witches. Not yet as black as Beelzebub, just a fairly ordinary cat. It was the Romantics who made the black cat a classic of the Gothic novel. The most famous, the story by Edgar Allan Poe, derives from the ancient tradition of walling a cat up in a house being built to make it strong. Little by little, the ugly hag and her cat became a

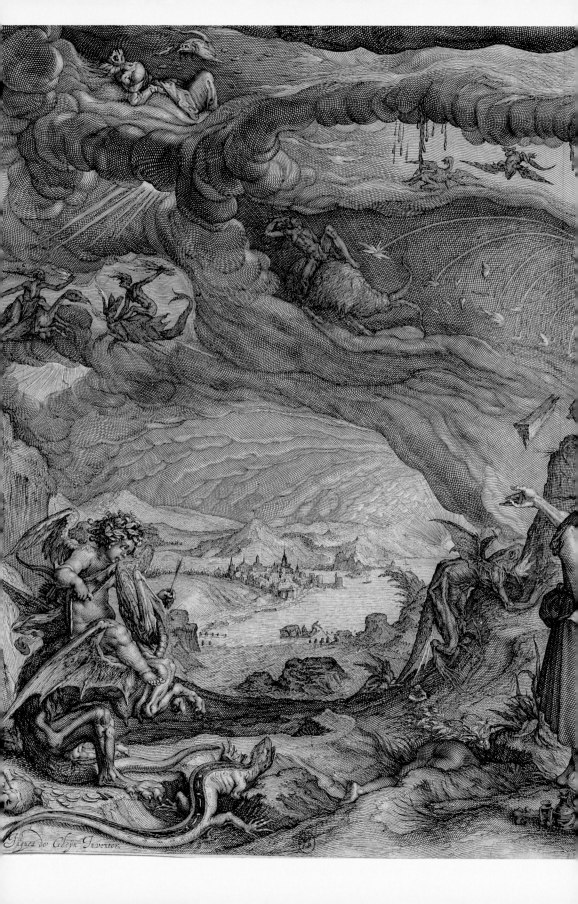

Jaques de Gheyn Inventor.

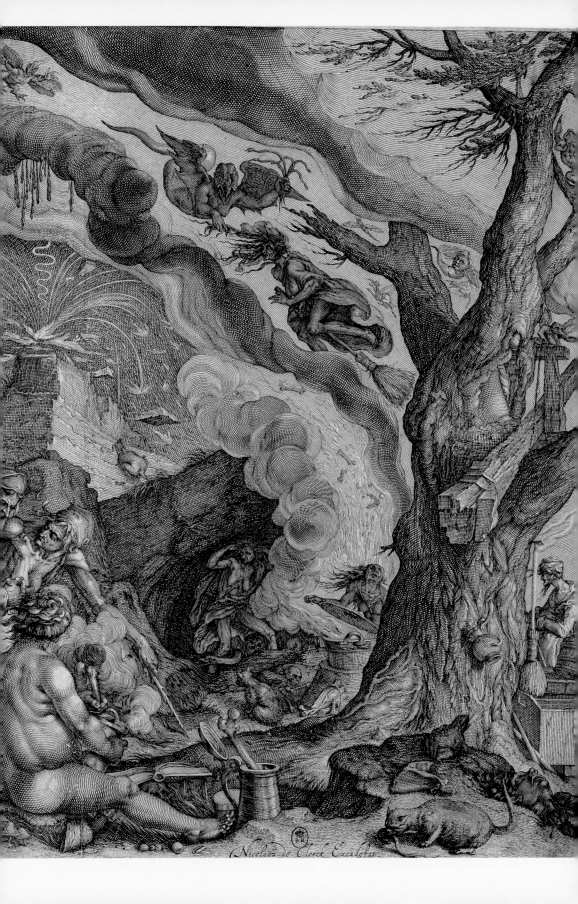

Nicolaus de Clerck Excudebat

natural pair, because old women are known to be fond of cats, whether beggar women, like the *Old Woman with a Cat* by Jacques Callot (see p. 125), or grandmothers or nurses sitting by the fire with a puss for company (see p. 124).

In the twentieth century, witches grew younger and more beautiful, especially in the cinema. In Richard Quine's 1958 film *Bell, Book and Candle* starring James Stewart and Kim Novak, a publisher is seduced by his bewitching neighbour with the help of sorcery and her Siamese familiar. But when the cat leaps on his shoulders, the publisher asks: "Hasn't this cat got anything better to do? Couldn't you give him something to read?"

123

"So good evening, my dear reader. Go home and lock your cage for the night, one never knows what might happen. The most peaceful nights can end in a storm."

♣ J.-J. Grandville (1803–47), print, illustration for page 4 of *Scènes de la vie privée et publique des animaux*, P.-J. Stahl ed.
Estampes et Photographie, DC-199 (D) FOL, t. 6

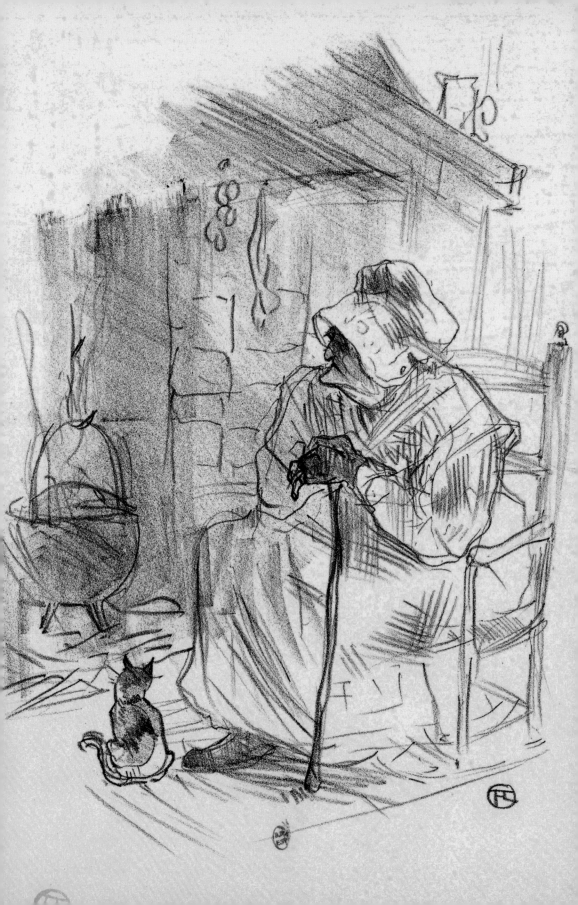

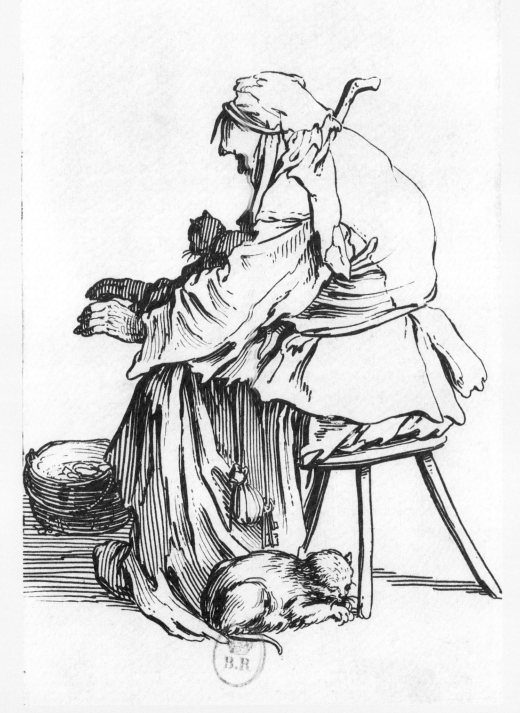

125

繪兄弟

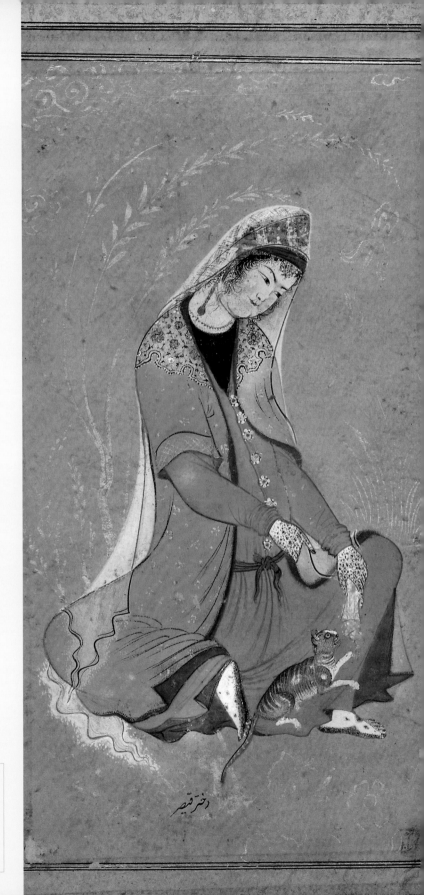

❖ "Lady playing with
her Cat", illumination,
Iran, late 16th century
Manuscrits, Supplément
persan 1171, fol. 12v

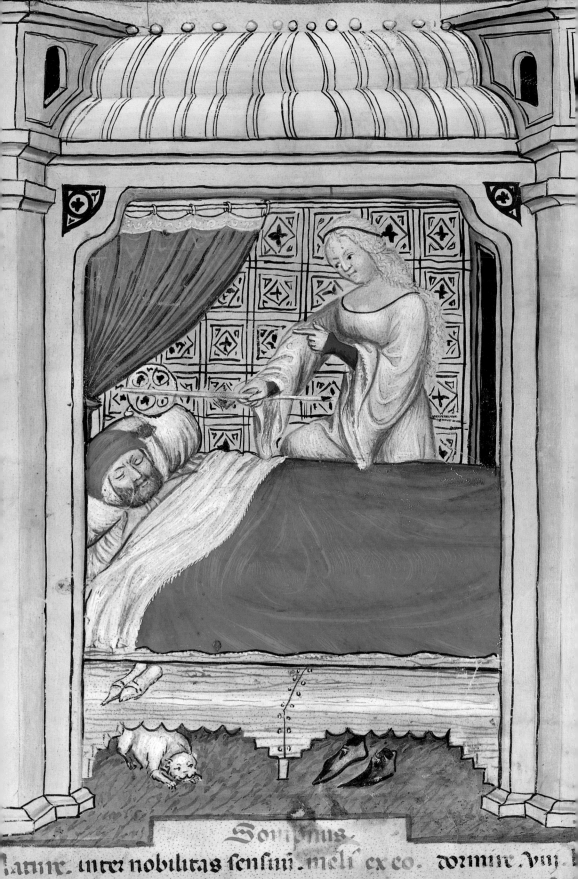

latine. inter nobilitas sensum melī ex eo. dormire. vij.
a medus inter dnas. rimus et auns ultimus noœus. Tu

Although the cat is shown playing with women in the Oriental world, as in India, Bengal, China or Japon (see pp. 127-28), its presence is not interpreted in quite the same way as in Christian Europe where, since the Middle Ages, the cat has been associated with debauchery and adultery, as testified by the proverb "She lets the cat get the cheese" (see p. 135). In miniatures, a cat under a woman's bed is a bad sign... for her husband. In *Das Narrenschiff* (*The Ship of Fools*), a satirical poem written in Germany in 1494 by a humanist from Strasbourg, Sebastien Brant, the woman is tickling her husband who hides his face, while the cat catches mice under the table (see p. 134). This association persisted in engravings until the nineteenth century, and even longer in literature and the cinema. It is found in Émile Zola's *Thérèse Raquin* (1867), in which the accusing stare of François the cat reminds the lovers of their crime. And Marcel Pagnol, in *The Baker's Wife* (1938), enriched Jean Giono's original story with the famous scene in which the baker upbraided the cat Pomponnette, the feline double of his unfaithful wife.

❧ "A Woman Fanning a Man Asleep in a Bedroom", miniature in a *Tacuinum sanitatis*, illuminated manuscript, Lombardie, ca. 1400
A cat under a bed is often a sign of adultery, as it probably is in this "health manual".
Manuscrits, NAL 1673, fol. 89v

❧ "I wake the sleeping cat", illustrated proverb in *Livre d'heures à l'usage de Rouen*, illuminated manuscript, Rouen, late 15th century
Manuscrits, NAL 3134, fol. 18v

130

♣ "Fauna: Grasshopper, Cat, Fly, Dragonfly, Cray-
fish, and Architectural Drawing: Maze", Villard de
Honnecourt, Sketchbook, 1230?
Manuscrits, Francais 19093, fol. 7v

♣ "A madman plays the sackbut, while a cat
preens itself between its legs", margin illustration
in the *Heures à l'usage de Paris*, illuminated man-
uscript, 1480–1500
Manuscrits, Latin 1393 fol. 138

ton filz pour moy pouire
rechrasse.

Ihuarist fontaine de
charite qui iamais
ne tint qui par affection
piteable dez pendant en
larbre de la croix que tu
auois soif cest a dire du
salut de lumain lignai
ge Ie te prie enlumme et
eschaufe mon desir a fai
re et pfaire bon oeuure
et refroidis et estains du
tout en tout la soif de co
cupiscence charnelle et la
petit de dilection modui
ne qui est en moy ame

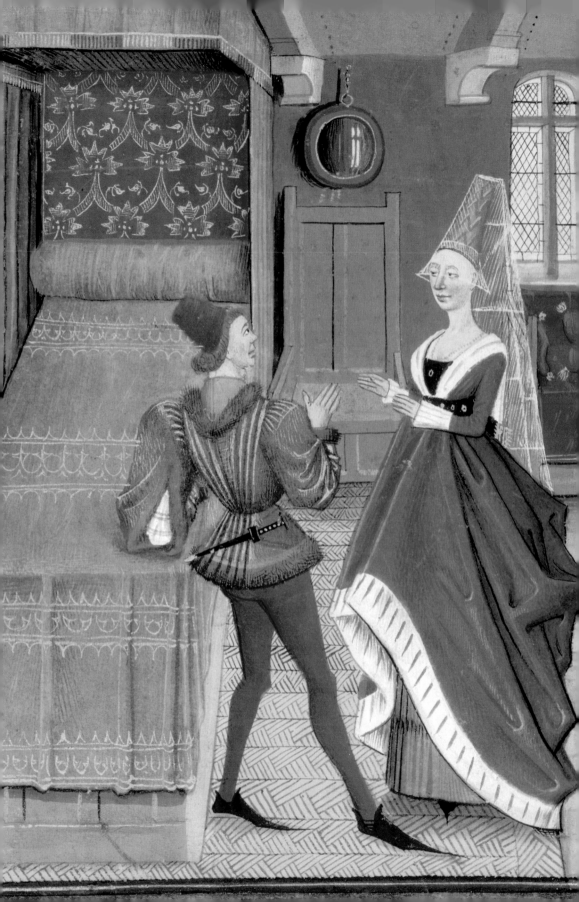

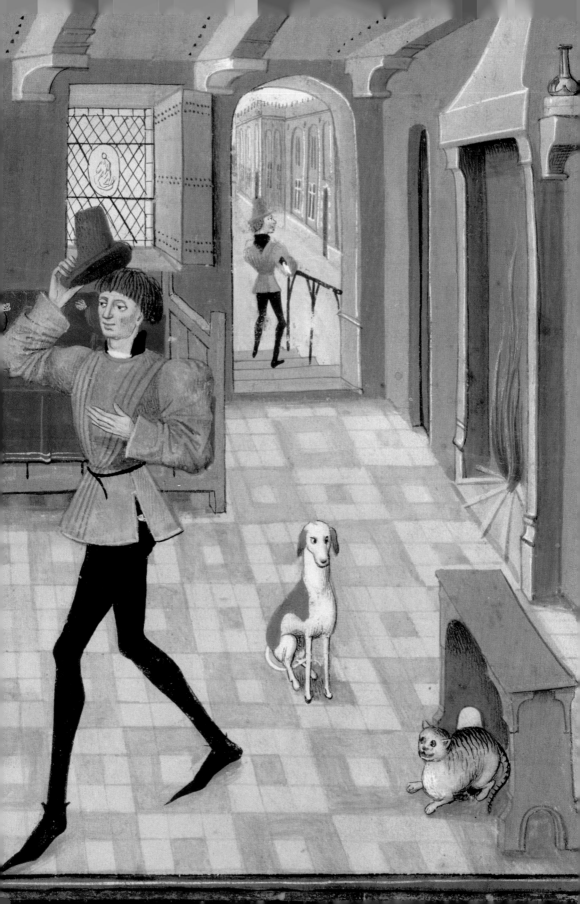

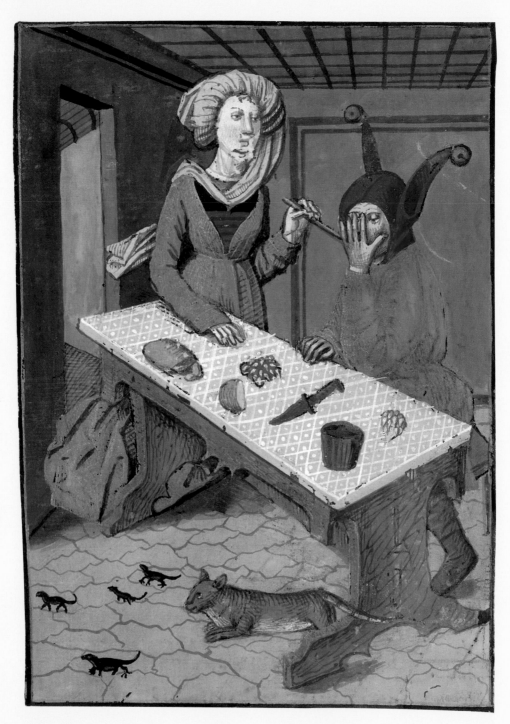

134

🐾🐾 "Beuves d'Aigremont is Comforted by his Wife", Loyset Liedet miniature for David Aubert's *Renault de Montauban*, manuscript created for the Duc de Bourgogne Philippe le Bon in 1462

The presence of the cat and the dog is highly symbolic in this medieval best-seller, which tells of fidelity and betrayal.
Arsenal 5072, fol. 202v

Tirant les vers du nez
il gagne le pais bas,
Ainsy s'en vàt le chat
doucement au fromage,
Mais a bon chat bon rat
elle ne laisse pas,
D'empescher quil n'ayt
sur elle cette auantage.

Il luy tire
les vers
du nez.

a bon bon
chat Rat.

De bon fromage, mange peu,
si tu es sage.
Mariez vous cest chose honneste
n'en feré pas mary, mais
e soyez pas si beste que
espouser vostre mary.

l gagne le pais bas

7 Elle laisse aller le Chat au fromage.

❧ "The Cuckold", Sebastian Brant (1457–1521), *La nef des fols du monde,* printed on vellum with illuminations, Paris, 1497
The cat chasing mice under the table symbolises uncontrollable female desires.
Réserve des livres rares, VELINS-607, fol. XXVII

❧ "She Lets the Cat get the Cheese", Jacques Lagniet (1600?–1675), *Recueil des plus illustres proverbes...,* Paris, 1663
Estampes et Photographie, Réserve TF-7-4, p. 65

Cats can see well in the dark and are often shown beside a looking-glass in allegories of Sight, such as that of Jan Saenredam, which associates a cat, a mirror, and a naked woman gazing at her reflection. From there it was only a short step to make the cat symbolise female coquetry, as in Hieronymus Bosch's *Tabletop of the Seven Deadly Sins* in the Prado in Madrid.

At the end of the seventeenth century, religious or moral allegory gradually gave way to libertine innuendo. In Europe, the cat quickly ousted the lap-dog, *de rigueur* in seventeenth-century engravings of courtesans. As late as 1853 William Holman Hunt's moralistic painting *The Awakening Conscience,* now in the Tate Gallery in London, shows a cat under the table of a prostitute suddenly stricken with remorse. In Japan, too, cats were often associated with sensual or venal women. The famous print of a short-tailed – and therefore typically Japanese – cat on a windowsill, in Utagawa Hiroshige's *Views of Edo* (1856–58), is also a view of a courtesan's house, as the bowl, towel, and hairpins reveal. The Japanese word *neko* is used both for the cat and the female sex (see pp. 142-43). This homonymy, also found in Europe, is lavishly exploited in erotic prints. During the Enlightenment, a woman at her toilette was often shown with a cat twined about her ankle. The same theme is found in the well-known *Lever de Fanchon* (1773) by Nicolas-Bernard Lépicié, in the Hôtel Sandelin museum in Saint-Omer, and the variously explicit prints derived from it. "The exquisite cleanliness of the cat has probably led to its having been compared, by all peoples, in all ages, to woman", wrote Champfleury in *The Cat. Past and Present* (p. 138). This "exquisite cleanliness", which took on a negative, or even obscene or scatological slant in medieval illuminated manuscripts (see p. 130-31), was appreciated in nineteenth-century bourgeois homes, although the presence of a cat near a woman at her toilette still adds an erotic, forbidden note, because a naked woman is necessarily a loose woman. Charles Baudelaire advised his friend Édouard Manet to put a black cat at the feet of his scandalous *Olympia* (see pp. 144-45), a transparent allusion to Jeanne Duval, his feline mistress, whom he celebrated in "The Cat", a famous poem in *Les Fleurs du mal*, first published in 1857:

❧"Cat behind a Windowpane", Utagawa Hiroshige (1797–1858), print
Estampes et Photographie, Réserve DE-10 Boîte FOL

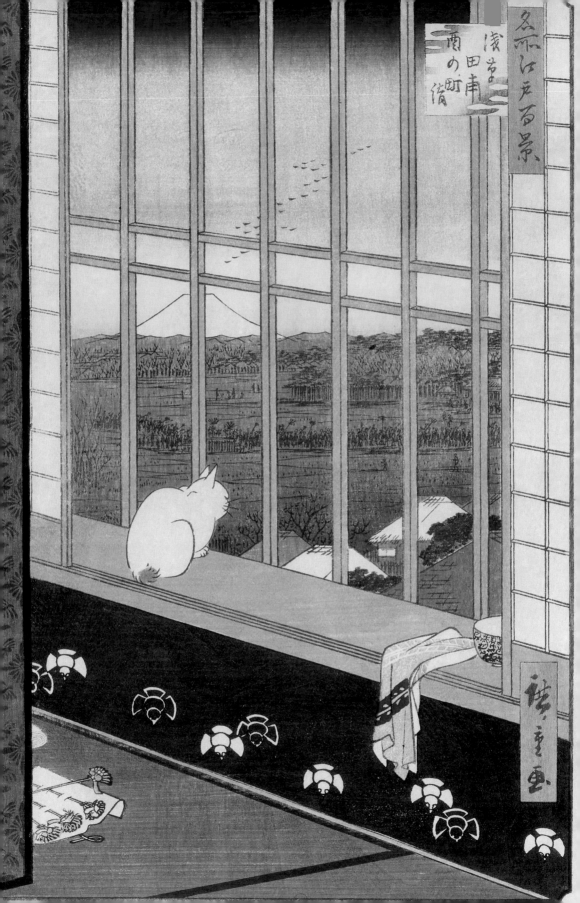

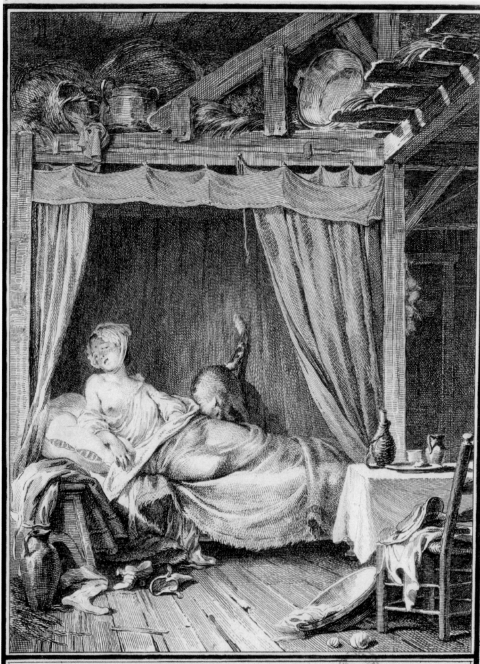

Tenés, l'autre nuitée.
Tandis que je dormois,

♣ "The Innocent", Jean-Michel Moreau (1741–1814), print for *Choix de chansons mises en musique par M. de La Borde*, Paris, De Lormel, 1773
Réserve des livres rares, SMITH LESOUEF-R-1842, t. 1

❀ "Misunderstanding", Jean Louis Anselin (1754–1823), engraving from a painting by François-Nicolas Mouchet (1750–1814), last quarter of the 18th century
Estampes et Photographie, AA-3 (MOUCHET)

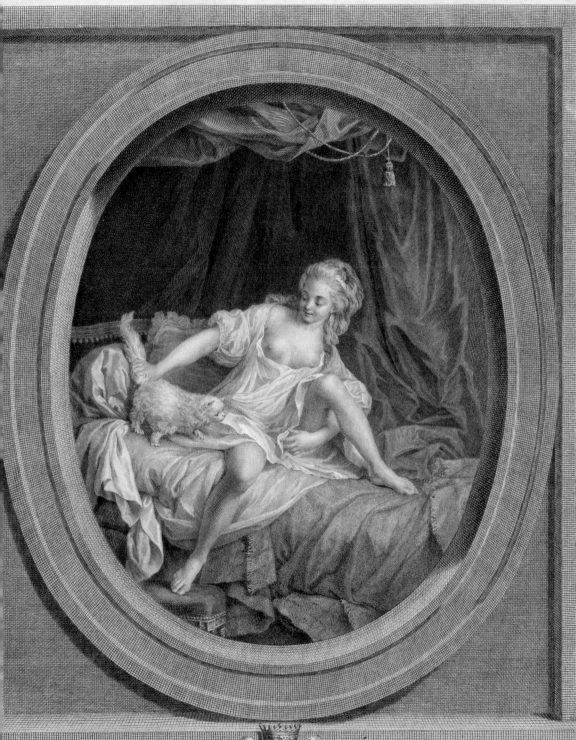

LA MÉPRISE

Dedieé a Mr. Cr. Louis Cheveny de la Chapelle

Par son tres affectioné Cousin Mouchet

Commencée a Graver par Macret et terminée par Me.

Se vend a Paris chez Mouchet Quay de Bourbon, Isle St Louis No 9.

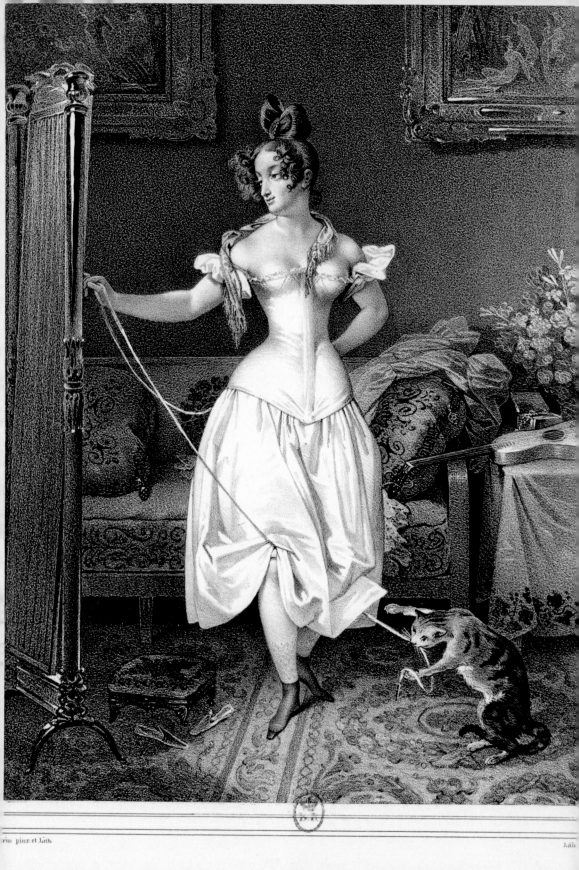

LE LACET.

Come, my fine cat, against my loving heart;
Sheathe your sharp claws, and settle.
And let my eyes into your pupils dart
Where agate sparks with metal.

Now while my fingertips caress at leisure
Your head and wiry curves,
And that my hand's elated with the pleasure
Of your electric nerves,

I think about my woman – how her glances
Like yours, dear beast, deep-down
And cold, can cut and wound one as with lances;

Then, too, she has that vagrant
And subtle air of danger that makes fragrant
Her body, lithe and brown.
(trans. Roy Campbell, New York, Pantheon Books, 1952)

❧ "The Lace", Nicolas-Eustache Maurin (1799–1830), lithograph
Estampes et Photographie, DC-118, t. 1

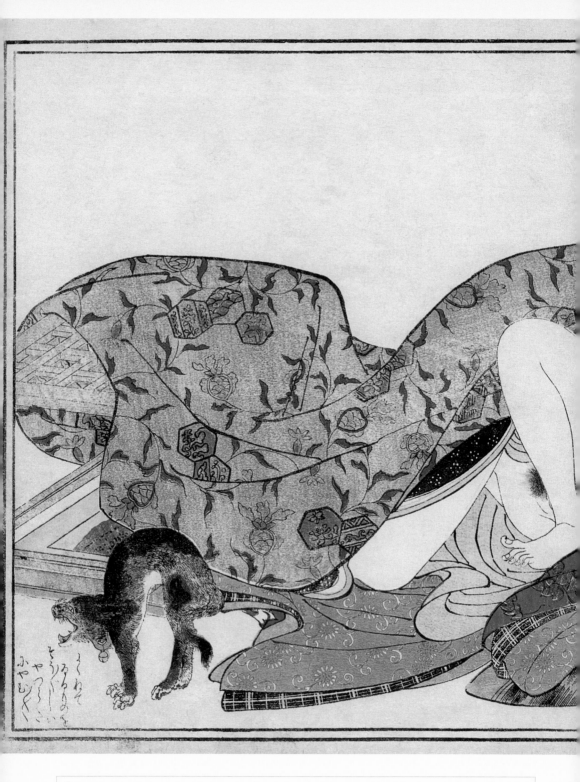

♣ "Ah! Those two have disturbed my peaceful sleep! Meow... Meow...", Katsukawa Sunshô (1725–92), ninth print in a series of twelve in

L'Album érotique du coucou comique ou De l'adoration du sexe des femmes de la nuit, 1788
Estampes et Photographie, Réserve DE-17 (JB-582), Boîte écu

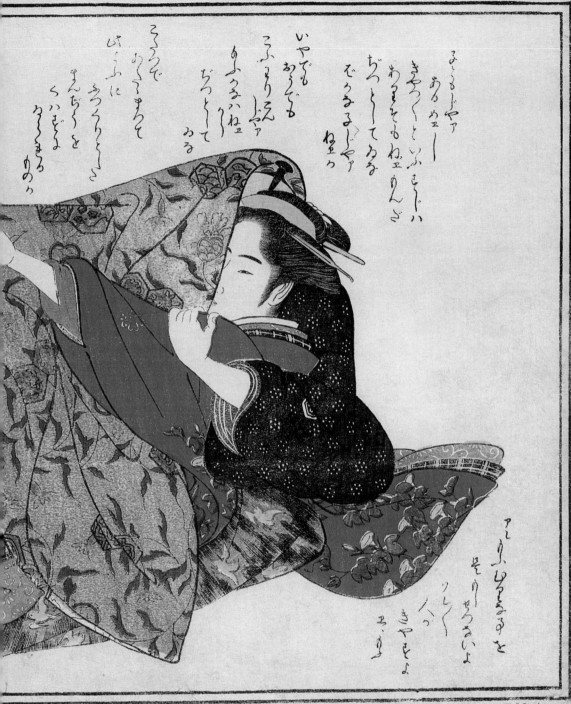

G. Marteau.

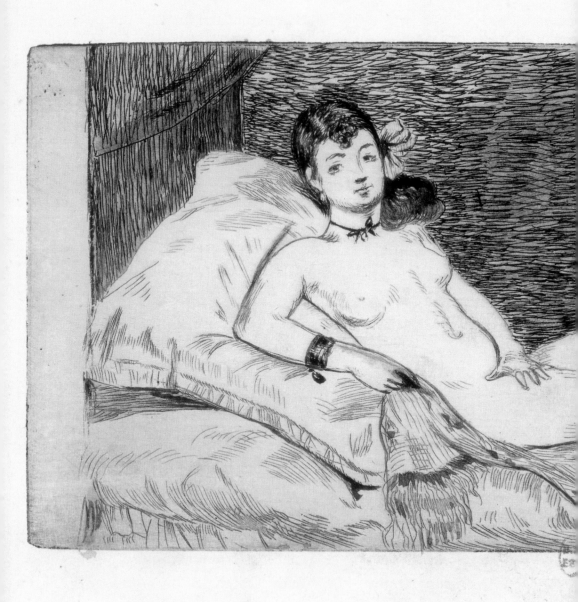

♣ "Olympia", Édouard Manet (1832–83), etching,
first state, retouched with blue ink, 1867
Estampes et Photographie, Réserve DC-300 (D, 2) FOL

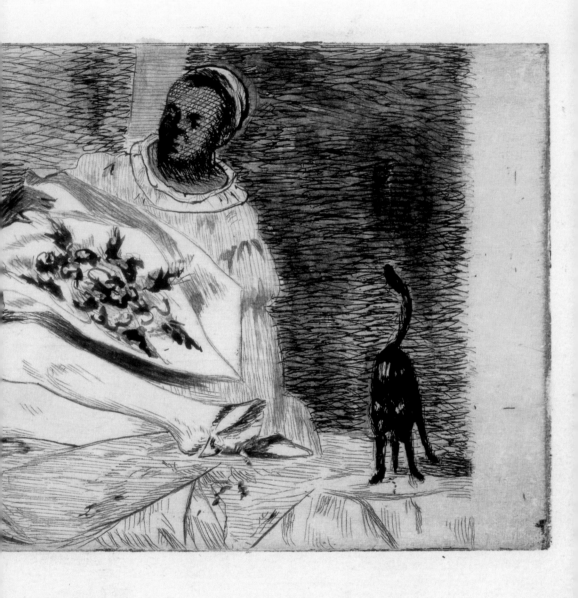

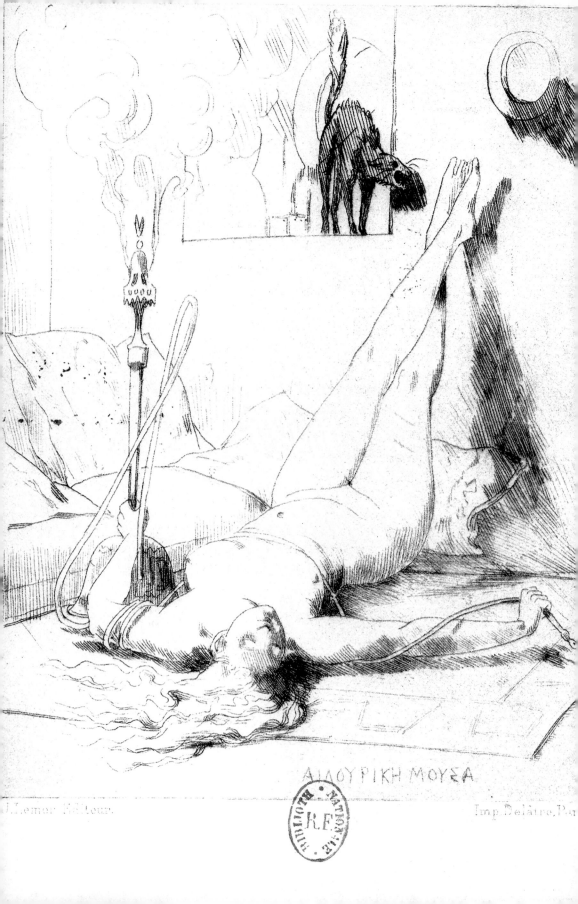

ΑΙΛΟΥΡΙΚΗ ΜΟΥΣΑ

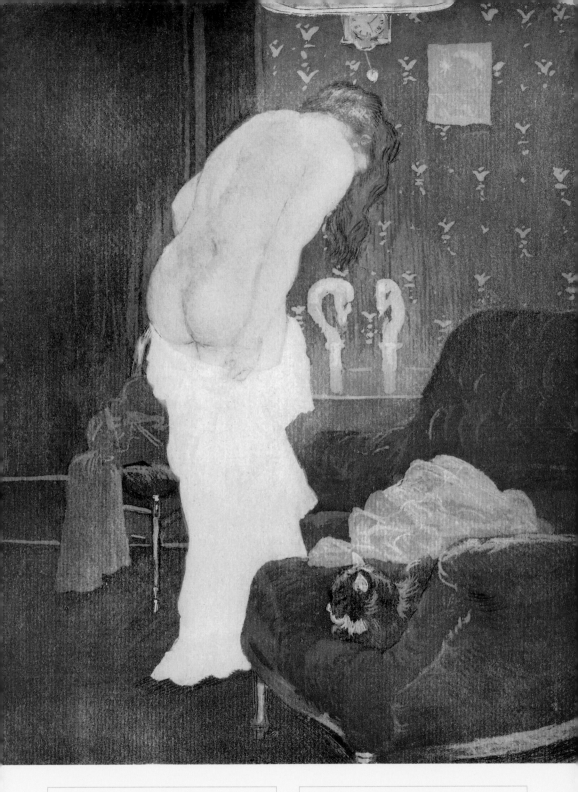

❧ "Muse with a Cat", Auguste Delâtre (1822–1907), frontispiece of *Parnassiculet contemporain: recueil de contes nouveaux… orné d'une très étrange eau-forte*, Paris, 1872

Littérature et art, YE 29528

❧ "Bathroom", Charles Maurin (1856–1914), colour aquatint, Paris, 1890–1900

Estampes et Photographie, DC-617 FOL, t. 1

Poets and artists drew analogies between the *femme fatale* and the cat, and emphasised their common traits of beauty, sensuality, treachery, and cruelty. Here, for instance, in Paul Verlaine's *Poèmes saturniens,* especially in "Caprice I. Woman and Cat":

She was playing with her cat, and
It was marvellous to see
The white paw and the white hand
Fencing with the evening shade.

She was hiding (sheer wickedness)
Under black-thread mittens
Murderous agate nails
As clear and cutting as razors.

The other one was at the same
Sweet game, razor claws
Hypocritically drawn in…

And in the bedroom where her laugh was bright
As a bell
Four points of phosphorus were alight.
(trans. Martin Sorrell, Oxford University Press, 1999)

LA PARESSE

♣ "Laziness", Félix Vallotton (1865–1925), woodcut, 1896
Estampes et Photographie, DC-292 (C, 2 bis) FOL

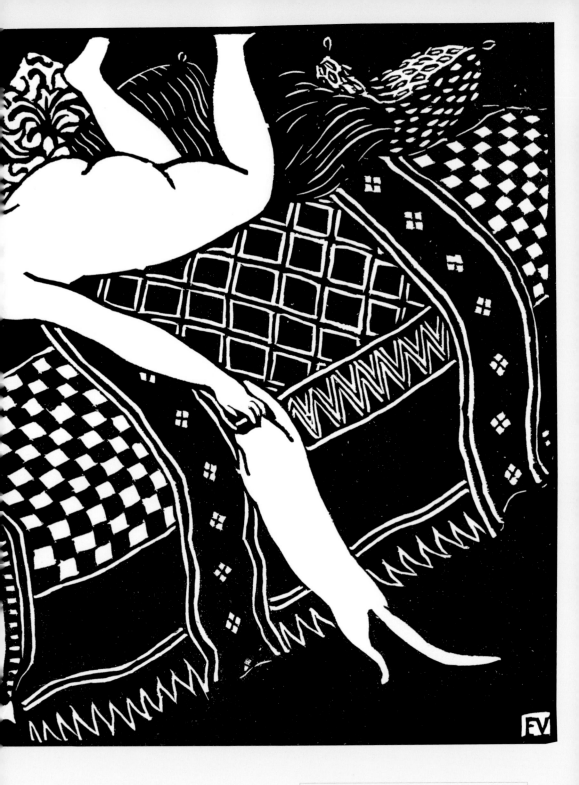

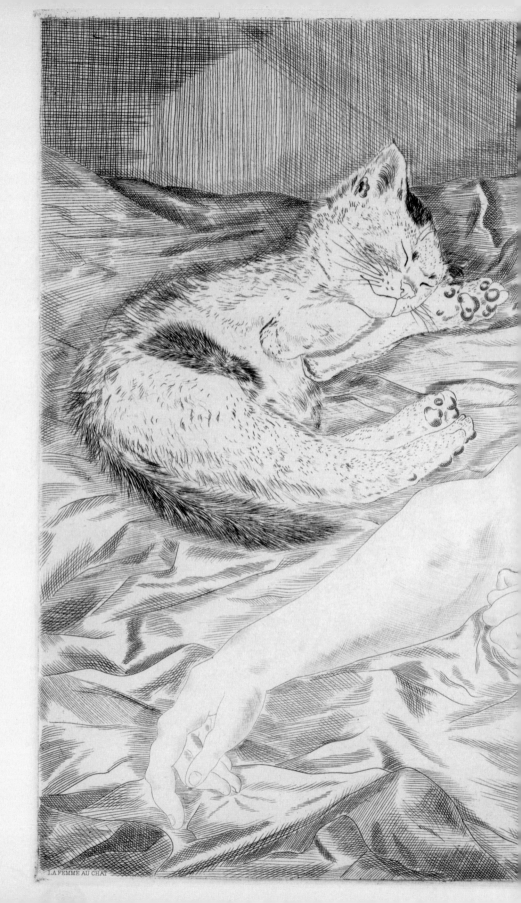

LA FEMME AU CHAT

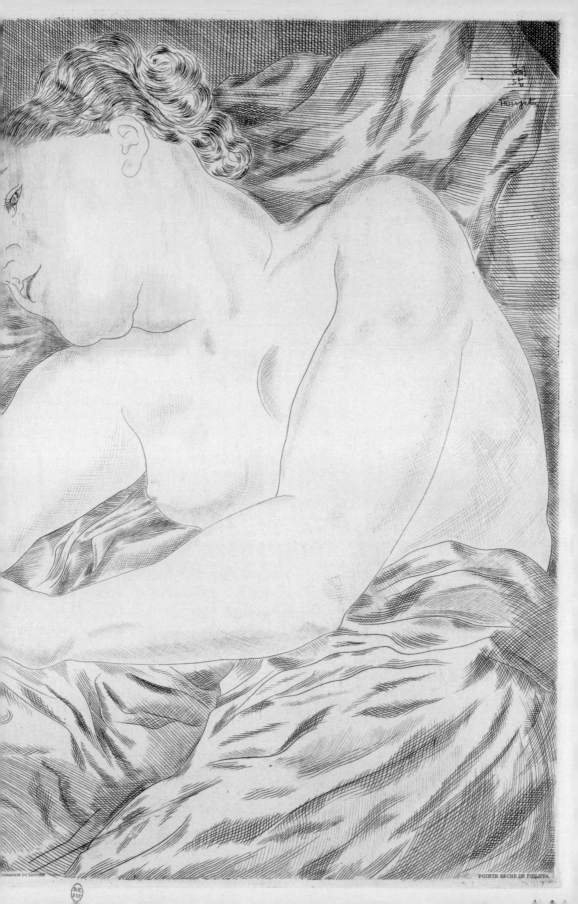

Charles Cros was content to eroticise them both without moral undertones in a poem less often quoted than his famous "White Cat", "Corner of a Picture. Sensation of Hashish", in *The Sandalwood Chest**:

> Warm and white was the breast
> White, quite white, the cat.
> The breast lifted the cat,
> The cat clawed the breast.
>
> The ears of the cat
> Cast a shade on the breast
> Pink tipped was the breast
> Like the nose of the cat.
>
> A black mark on the breast
> Long intrigued the cat;
> Then to other games the cat
> Leapt, baring the breast.

These frequently quoted texts often make us forget that from the nineteenth century onwards, the cat, particularly in English-speaking countries, embodied the comfort of the home. It then became legitimate to show a cat beside the wife or mother of the household, particularly as a female cat was often associated with maternal love. That is how the cat clawed back its long-lost dignity and acquired middle-class respectability, for which it probably cared little, but which provided a lifestyle that the feline epicurean unscrupulously savoured alongside its doting masters.

❧ "Lily or the Woman with a Cat", Jacques Villon (1875–1963), drawing
Estampes et Photographie, EF-437, FOL t. 1

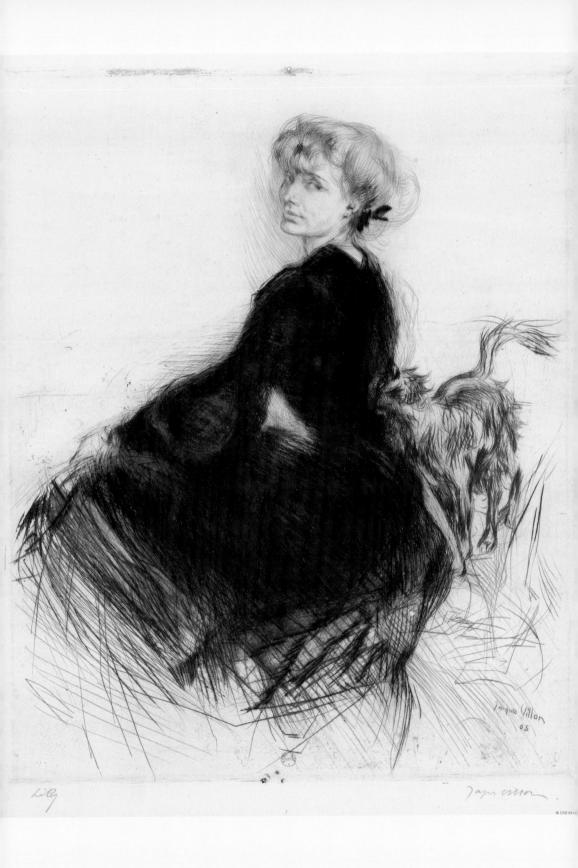

Jacques Villon

154

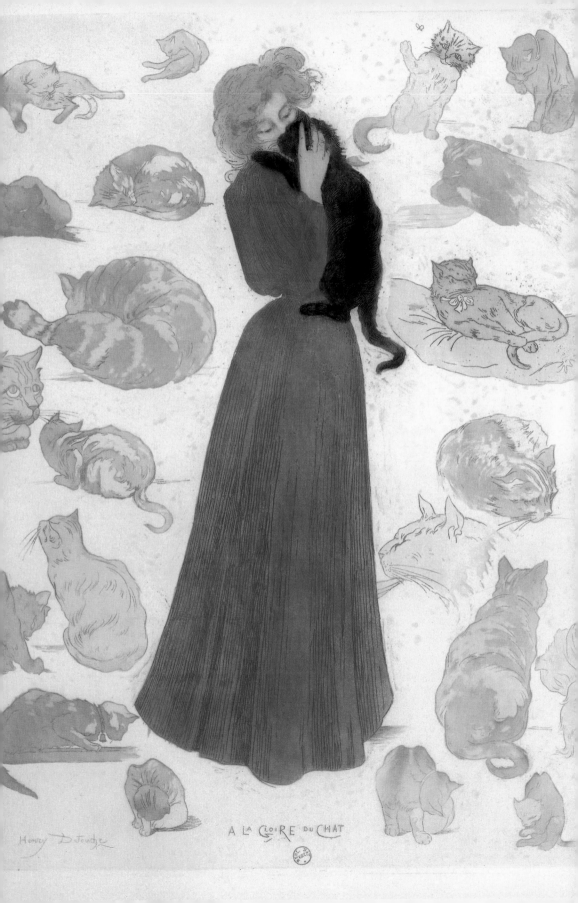

A LA GLOIRE DU CHAT

“ A poet's cat, sedate and grave,
As poet well could wish to have,
Was much addicted to inquire
For nooks to which she might retire,
And where, secure as mouse in chink
She might repose, or sit and think.
I know not where she caught the trick
Nature perhaps herself had cast her
In such a mould philosophique,
Or else she learn'd it of her master. ”

William Cowper, *The Retired Cat*

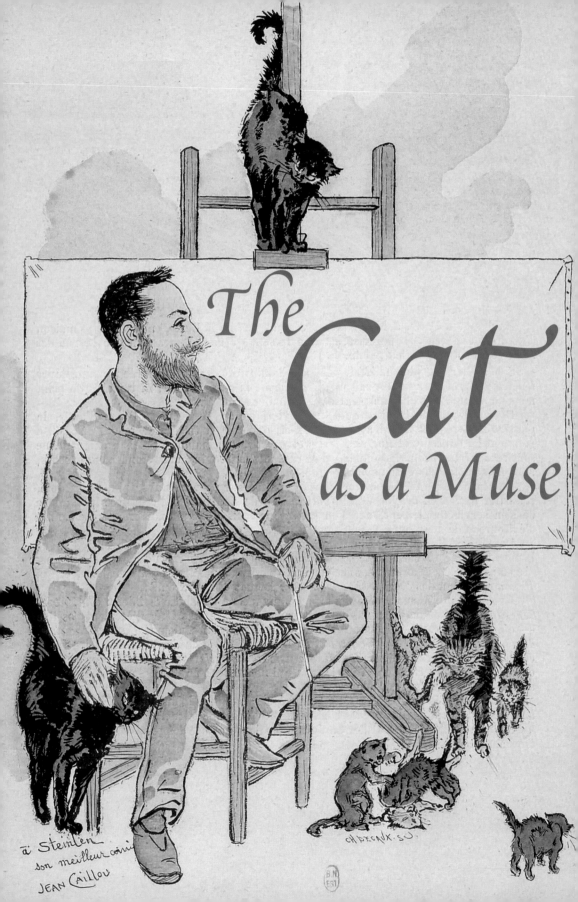

The **Cat** as a Muse

à Steinlen
son meilleur ami
Jean Caillou

CH. DECAUX. SC.

As Pierre Rosenberg pointed out in *The Painted Cat: the Cat in Western Painting from the Fifteenth to the Twentieth Century* (New York: Rizzoli, 1988), it is harder to measure a passion for cats among painters than among writers. And yet it can be surmised from the many little pussies frisking in the margins of illuminated manuscripts and tomcats in the details of paintings; if it seems to be the same one, we can hazard a guess that it is the artist's pet cat, Philippe de Champaigne's tabby, for instance. In 1855, Gustave Courbet put his superb white angora cat in the foreground of his *Atelier*, and Champfleury among the onlookers. In the next century, Tsuguharu Foujita (1886–1968) painted himself busy writing with his tabby cat leaning on his shoulder (see p. 168); indeed there are very few of his paintings, whatever the subject, which do not have a cat somewhere. In the late eighteenth century we see the first animal painters specialised in cats, such as the Swiss Gottfried Mind (1768–1814), who was known as "the Raphael of cats". Many more followed in the Victorian period: the Belgian Henriette Ronner-Knip (1821–1909) and the Frenchman Louis-Eugène Lambert (1825–1900) (see p. 12). In 1877, a set of twenty-four prints by Méaulle after Lambert's paintings was published by Hetzel. It would be tedious to list all the artists who painted cats in the twentieth century. We might just quote Colette's best illustrator, the painter, sculptor and poet Jacques Nam (1881–1974) (see pp. 190–91). The Swiss draughtsman, caricaturist and engraver Théophile Alexandre Steinlen did not confine himself to the many cats he lived with. Yet he is famous for his cats – from the poster for the tour of Rodolphe Salis' cabaret "Le Chat noir" to a small sculpture of a seated angora. He was probably well aware of it because he chose a black cat in profile beside a tortoiseshell cat for the poster for his first solo exhibition "À la Bodinière". Cats were not lacking in the Impressionists' works either, particularly in those of Édouard Manet. In Manet's work, cats were not only a likeable subject, but also a sign of a particular friendship, such as that between Manet and Baudelaire.

❀❀ "Steinlen at his Easel", Jean Caillou (pseudonym of Théophile Steinlen, 1859–1923), plate for *Les hommes d'aujourd'hui*, no. 349, 1889, dedicated to Steinlen by J. Caillou...
Estampes et Photographie, DC 385 (7) FOL

❀ "The Cat and the Flowers", Édouard Manet (1832–83), first state, blue ink, etching and aquatint, printed for the third edition of Champfleury's *Chats*, 1869
Estampes et Photographie, Réserve DC-300 (D, 3) FOL

Shortly after painting *Olympia*, Manet drew "The Cats' Rendez-vous" and "Cat with Flowers" (see pp. 173 and 160) for Champfleury, who often quoted the author of *Les Fleurs du mal*. The Japanese influence on French painters made the cat a favourite model: it is often found in the work of Henry Guérard, who with Braquemond co-founded the Société des peintres-graveurs, or in that of Eugène Delâtre (see pp. 146, 184–85, 195). Pierre Bonnard liked to put cats in his paintings: the cat nursing her kittens in *A Bourgeois Afternoon, or The Terrasse Family* (1900) (collections of Musée d'Orsay) is a case in point. He painted his friend, the collector Ambroise Vollard, on several occasions with a cat on his lap. Balthus's first work, produced in 1919 when he was eleven, was the story of finding and losing his cat Mitsou. His set of naive lithographs was published in 1921 thanks to Rainer Maria Rilke who, yet again opposing cats and dogs, wrote in the preface*:

> Cats are just cats, and their world is a cat's world from end to end.
> You think they're looking at us. But can we ever be sure that they
> deign to hold for an instant our futile image on their retina?

The cat's independence and its latent wildness, grounds for criticism in Buffon, became assets in the following century, which held writers in particular esteem. The cat symbolised freedom, by contrast with the dog's servility, so it appealed to creative people, artists, musicians, and writers. "What I like in the cat is its independent, almost ungrateful character, which means it is never attached to anyone, the indifference with which it goes from the drawing-room to its native alleyway", Chateaubriand wrote to the comte de Marcellus. Eventually, a positive association of the cat and freedom emerged toward the end of the Enlightenment. It may have come from Rousseau. Jean-Jacques did not say much about his cats although an engraving after a drawing by Jean Houel shows him at Montmorency in 1759, with his cat Doyenne on his lap and a dog at his feet. Incidentally, we know that he chose the vignettes for the title pages of the first edition of *On the Social Contract* (1762): there is a cat sitting at

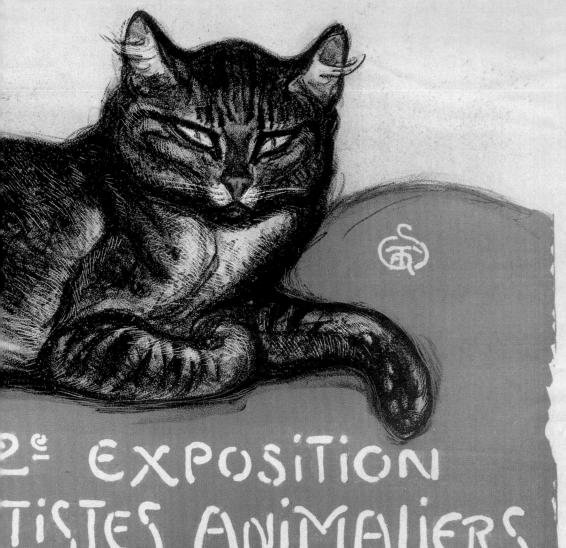

2e EXPOSITION
TISTES ANIMALIERS
TERNATIONAL DES ARTS
UL⁰ RASPAIL
(PRES LA RUE DE RENNES)

🐾🐾 "2nd exhibition of animal artists…, from 30 March to 25 April 1909", poster by Théophile Steinlen (1859–1923), lithograph
Estampes et Photographie, DC-385 (G) FT 5, t. 1

🐾 "Self-portrait with a Cat", Tsuguharu Foujita (1885–1968), drypoint, 1927
Estampes et Photographie, DE-20 FOL, t. 1

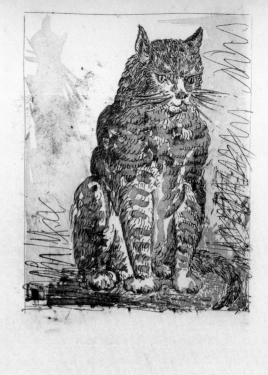

the feet of the standing figure of Justice, in one, and beside Liberty, in the other. The sculptor Pierre-Nicolas Beauvallet, who later produced "Liberty in the Ruins of the Bastille" is attributed with a low relief in the king's bedchamber at Compiègne, carved in 1784, in which a cat is sitting proudly opposite Liberty. The French Revolution, which honoured Rousseau among the great men in the Panthéon, adopted this allegory. So the cat appeared in *Iconologie* by Gravelot and Cochin published in 1791. In 1795, it pops up in an engraving by Jacques-Louis Copia representing the Constitution. This work was taken from an engraving by Pierre-Paul Prud'hon in 1793 who commented on his allegory himself in 1798 (Quoted by Jacques Berchtold, "Jean-Jacques Rousseau's Cats", *Literary Dogs and Cats** […], Geneva, La Dogana, 2002, p. 94):

A domesticated animal which has never been reduced to servitude,
a cat, the emblem of Independence, is sitting at Liberty's feet.

♣ "Cats", Pablo Picasso (1881–1973), *Eaux-fortes originales pour des textes de Buffon illustrés par Picasso*, Paris, M. Fabiani, 1942, copy on Vidalon vellum which Picasso gave Dora Maar on 17 January 1943; it contains 44 original pen-and-ink wash sketches done by Picasso on 24 January
Réserve des livres rares, RES-G-S-95

The alley cat, a sort of feline bohemian, is a recurrent theme in Romantic literature, symbolising adventure, freedom and love. Grandville illustrated the theme for Balzac's *The Heartbreak of an English Cat* and for Hoffmann's *Tomcat Murr*. Manet depicted it magnificently in *Le Rendez-vous des Chats*. The starving but free stray cat is opposed to the lap-cat, just as the artist or poet in his garret is opposed to the bourgeois in his oppressive, opulent drawing room. In Octave Tassaert's *Atelier* (1845, Louvre) the cat is the impoverished young painter's sole companion. Zola shattered the myth of the alley cat's life in "The Paradise of Cats" published in *Stories for Ninon*, his first book, before exposing the reality of bohemian life in *Claude's Confession** the following year. The Romantics' cat is black, a nocturnal rather witch-like creature with eyes that see in the dark, like the one tailing the Combourg ghost in Chateaubriand's *Memoirs* or, most famous of all, Edgar Allan Poe's cat illustrated by Aubrey Beardsley. It was not by chance if Rodolphe Salis called the cabaret he opened at the foot of Montmartre in 1881 "Le Chat noir," or that it attracted writers and artists

and became the emblem of a bohemian dream. The poster designed by Steinlen for the cabaret's 1896 tour shows an archetypal neo-Gothic cat, scrawny, ragged, with baleful yellow eyes, silhouetted against a pale moon. A cat that fires the imagination and does not seem altogether of this world, a cat for a shadow theatre. In phase with the end of the century, it hovers between Satanism and the folklore of Montmartre. Georges Courteline plumped for Montmartre, giving his cats names like Le Purotin, La Terreur de Clignancourt, La Mère dissipée or Le Rouquin de Montmartre.

In the next century, cats toyed with anarchy and revolt. In 1945, Boris Vian took the title of a piece of jazz and playing on the words as usual wrote a new song called "Blues for a Black Cat" in which a cat, a Resistance fighter but a roughneck too, did a bar crawl. The cat was likeable because of its resistance, albeit passive, to the established order. Cocteau's witty remark that he liked cats because there is no such thing as a police cat is well-known. And yet there are detective cats. The two Siamese cats invented by the American Lillian Jackson Braun have figured in thirty novels since 1966. More original is the comic char-

❖ "My silence encouraged him, and he cried: Minette darling!", J.-J. Grandville (1803–47), illustration for *Les peines de cœur d'une chatte anglaise* by Honoré de Balzac, published in *Scènes de la vie privée et publique des animaux*, P.-J. Stahl ed. Estampes et Photographie, DC-199 (D) FOL, t. 6

acter created by Juan Diaz Canales and Juanjo Guarnedo in 1997. Blacksad is an anthropomorphic black-and-white cat working as a private detective in New York in the 1950s. A sort of feline Bogart, he is the hero of the streets, a jaded loner. But "felinothropy" no longer rhymes with philanthropy. Like Céline, whose famous cat Bébert accompanied his master to Berlin, risking his life because the Nazis hated cats (*North*, trans. Ralph Manheim, New York, Delacorte Press, 1972 [1960]), Paul Léautaud made cat-worship synonymous with misanthropy. We cannot resist the temptation to quote the atrocious letter he wrote, with unfortunately infectious jubilation, to a peasant who had accidentally shot his son when aiming at a neighbour's cat:

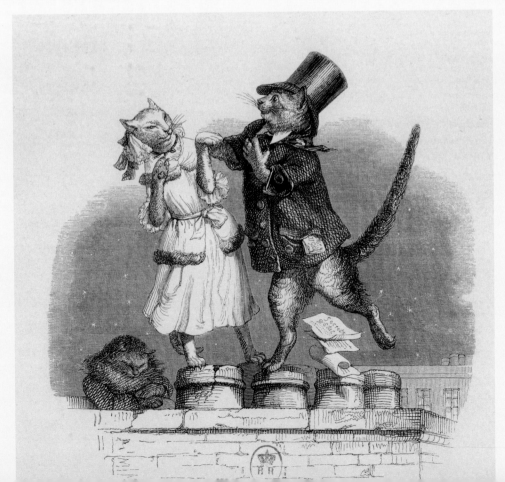

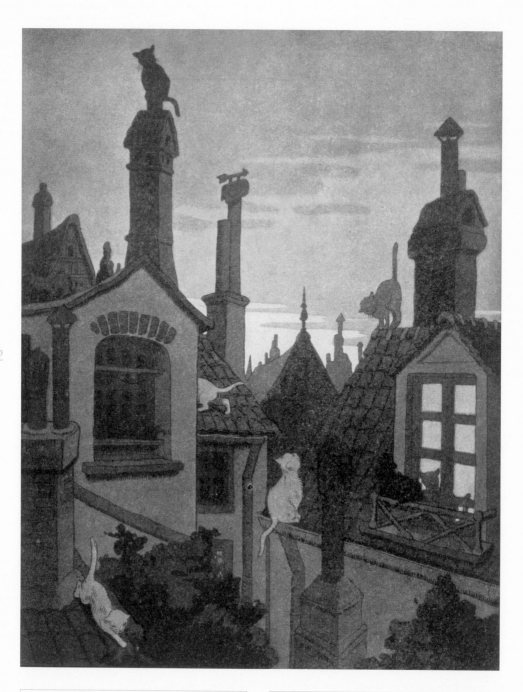

172

♣ Benjamin Rabier, *Le Buffon de Benjamin Rabier*,
Paris, Garnier, 1913, p. 39
Sciences et Techniques, FOL-S-1152

♣"The Cat's Rendezvous", Édouard Manet (1832–
83), lithograph for Champfleury's *Les Chats*, 1869
Estampes et Photographie, Réserve DC-300 (D, 4) FOL

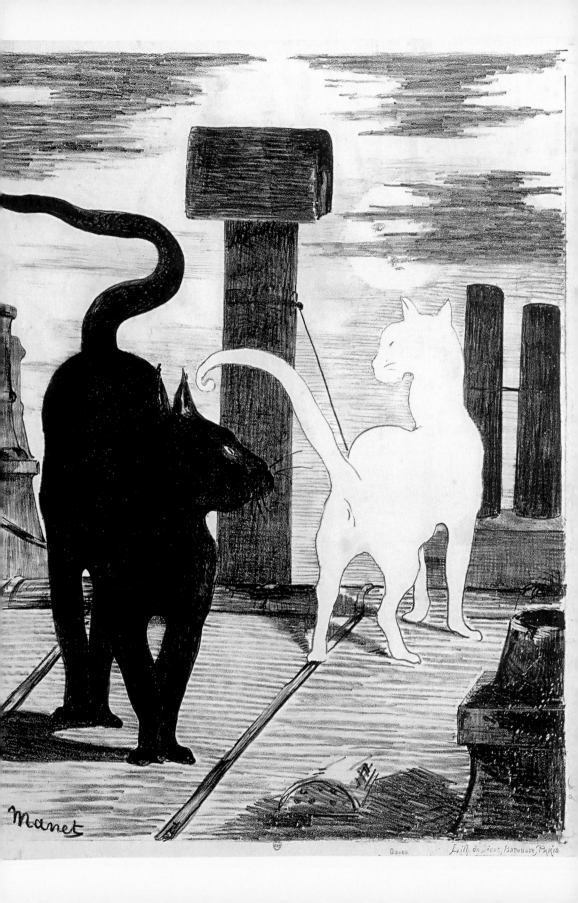

Paris, 29 April 1936

Sir,
I read in the paper about the "accident" which has just befallen you. Wanting to kill a cat, you killed your child. I am delighted. I am enchanted. I think that is perfect. That will teach you to be so cruel to a dumb animal.
Once again, all my compliments.

Cats these days do not seem to be politically correct. Just look at the recurring presence of what Terry Pratchett calls "the arch villain cat" in *The Unadulterated Cat* (1989), a dear little book which defends *realcatness*. The arch villain cat is a mega-baddie, who figures in films and comics as the antihero trying to become the master of the world or in the James Bond series. The stuff dreams are made on for fat cats on a cushion.

174

♣ "Paul Léautaud (1872–1956) and his Cats", Robert Doisneau (1912–94), photograph, ca. 1950
Estampes et Photographie, EP-19 Boîte FOL

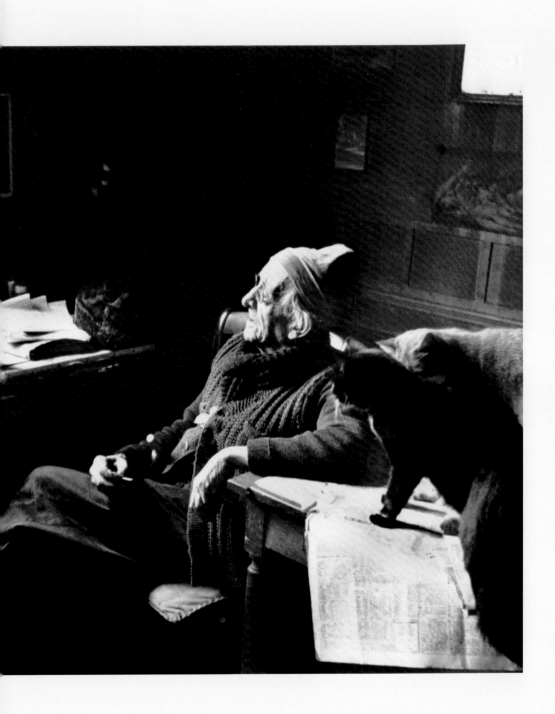

♣ "The Cat", Zao Wou Ki (born 1920), etching, 1950
Estampes et Photographie, DC-867 FOL, t. 1

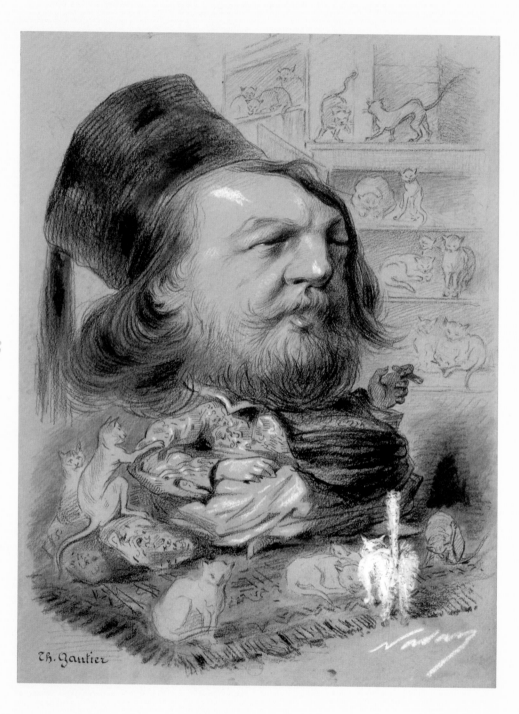

Th. Gautier

In the preface to his book, Champfleury notes that "the cat has deserted the alchemist's laboratory for the writer's study; he is now part and parcel of their humble lodgings [...]." Chapter 15, entitled "Concerning some Clever People who took Pleasure in the Society of Cats" listed in support of his passion the great writers of his time: Chateaubriand, Hugo, Sainte-Beuve, Théophile Gautier, Mérimée, and above all Baudelaire. In fact when his book was published, a great many artists, poets and writers kept a civilised, affectionate, peaceable cat, a real academician's cat. And many readily wrote about their companions, such as Théophile Gautier (*Private Zoo**), Alexandre Dumas (*Tale of My Animals**), Émile Zola "The Paradise of Cats" in *Stories for Ninon* (trans. Edward Vizetelly, New York, Richmond and Son, 1898) or Pierre Loti (*Lives of Two Cats*). Moncrif was the first to say: "Hatred of cats is a sign of mediocrity in an author." In a footnote he referred to the ode in which Ronsard expressed his dislike for felines, concluding that it was hardly surprising that the poet had sunk into oblivion. In the nineteenth century, particularly in France, as Christabel Aberconway remarked (*A Dictionary of Cat Lovers*, 1949, p. 17), the cat became a necessary attribute for any well-known or aspiring author.

179

❖ "Caricature of Théophile Gautier in the company of his cats", Nadar (1820–1910), charcoal, chalk and white gouache on light brown paper, for *Panthéon Nadar*, 1858
Estampes et Photographie, Réserve NA-88 Boîte FOL

❖ "Est A Minet. Mâche I coulis", Victor Hugo (1802-1885), *Notes and Drawings*, 1862
Manuscrits, NAF 13454, fol. 41v

✿"Collection of Portraits of Victor Hugo and his Family and Friends on Jersey (1852–55). Photos of the poet Charles Hugo and Auguste Vacquerie."
The poet, dramatist and journalist, Auguste Vacquerie, whose brother had married Léopoldine Hugo, was the executor of Hugo's will, along with Paul Meurice. He often visited the Hugo family during their exile in Jersey. He and Hugo's son, often on the poet's instructions, took photographs of the Hugo family and their entourage, which included Vacquerie's cat Miette.
Estampes et Photographie, Réserve NA-291-4

Je pensais à ma mère, à ma sœur, à Meurice,
à mon pauvre pays sans honneur et sans loi,
Je voyais brusquement, chère consolatrice
Et pendant un instant je ne pensais qu'à toi.

Oui, je t'aimais vraiment, compagne douce et fière
Rayonnement vivant sur tous les revers
Répandant ta gaîté, ta grâce et ta lumière
Consolant les proscrits après les prisonniers.

Et je t'ai franchement pleuré, je ne sais à peine
si je n'ai pas versé de l'eau vous plus d'un œil
mais cette fille était digne d'être la tienne
qu'étant née en prison tu sois mort en exil

Tu meurs trop tôt pour nous mais ta vie est complète
Et tu nous as laissé d'assez du deuil amer
Pour mériter la part que le destin t'a faite,
Victor Hugo pour hôte et pour tombeau la mer.

Auguste Vacquerie

Jersey, Juillet 1853.

This Gallic peculiarity can be explained by long-standing resistance to cats put up by the Cartesian approach popularised by Buffon; loving cats and saying so therefore became an affectation of originality and a blow struck against a petty-bourgeois spirit. Across the Channel where every home worthy of the name boasted at least one small cat, this did not happen. But many writers, such as Sir Walter Scott, Charles Dickens, and the historian Thomas Carlyle, still loved their cats. In 1896, Georges Docquois published *Beasts and Writers**, with a cover designed by Steinlen, which he dedicated to Fernand Xau. He interviewed writers such as Zola, Goncourt, Barrès, Anatole France, Barbey d'Aurevilly's friend, Louise Read, Courteline, Coppée, Loti, Daudet, and Mallarmé. All animals were concerned but cats had a clear lead over dogs and horses. The Bibliothèque nationale de France has two copies of the book, one dedicated to Anatole France and the other to Maurice Barrès. It is a forerunner of *The Pen Cat** which was published as a pocket book in 1985 and covered sixty writers. Interviews with authors in the press became common from 1880. They were usually illustrated. Barbey d'Aurevilly posed for Léon Ostrowsky with Démonette in the *Revue illustrée* of 1 January 1887, Huysmans paraded with a black cat drawn by Eugène Delâtre (see next page), and the poet François Coppée lived in the midst of a crowd of cats, like Paul Léautaud after him (see pp. 174-75). Even more so, he littered his letters to the beautiful Méry Laurent, Manet and Mallarmé's friend, with droll cat-like sketches. The academician signed himself "the old cat" and the lady was the "big bird" (see pp. 15 and 187). Victor Hugo doodled cats in the margin of his manuscripts (see p. 179), as did the philosopher Alain and Paul Valéry (see p. 186). Claude Lévi-Strauss drew a cat on a folder containing an article on "Baudelaire's Cats"*. The ladies followed suit: Judith Gautier, Colette (see p. 188) and Anna de Noailles.

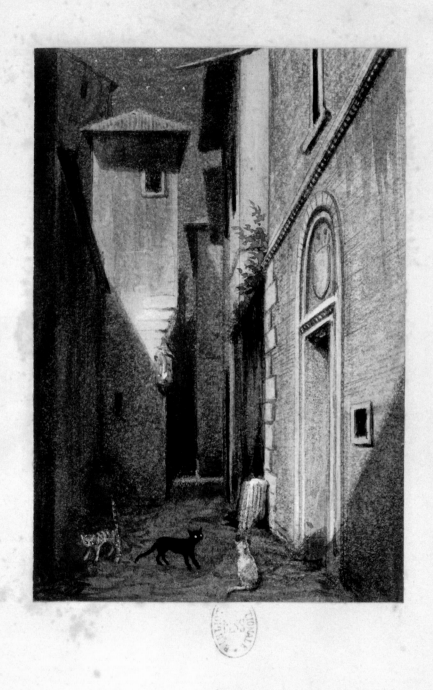

13

♣ Paul Valéry (1871–1945), Notes taken during Law Lectures, Montpellier, 1890

Manuscrits, NAF 19116, fol. 13

♣ Ernest d'Hervilly (1839–1911), letter to the actor Monval, who played the role of the story-teller in *Le bonhomme Misère* by Grévin and d'Hervilly

Manuscrits. Collection Théâtrale Henri de Rothschild, boîte/box 22

❧ François Coppée (1842–1908), letter to Méry
Laurent (1849–1900), 1881
Manuscrits, NAF 17357, fol. 12

❧ André Malraux (1901–76), "I love the cat [...]",
letter to Jean Grenier (1898–1971)
Although this letter talks about the cat Mouloud described in *Les Îles* (published by Grenier, Gallimard, 1933), it begins with the confession of a cat-lover.
Manuscrits, fonds Jean Grenier, NAF 28294

(Chats Nam)

"Chat sacré ! Chat de Siam ! Chat royal..." C'est bientôt dit. Là-dessus on ne me nourrit que de poisson et le riz. Le poisson est une bonne chose. Mais toujours du poisson ! (et du riz.) (...) du poisson... Croient-ils que mes origines siamoises, peut-être ma religion, me défendent de manger comme tout le monde ? Si je les écoutais...

Ils me nomment Chat. Pourtant je m'évertue à caninement les suivre, sur la plage, en forêt, et jusqu'au marécage grisant, gorgé de bêtes molles qui ploient sous les pattes. Et je me range, le long de la route, pour laisser passer les automobiles. Phares contre phares, les automobiles brillent blanc, et moi rouge. Rouge ! les phares verts du chat ? Si je les écoutais... Rouge ! Vos chats brûlent vert, comme les brebis. Mais il faudrait

❧ Colette (1873–1954), *Chats*, autograph manuscript [1936]
Manuscrits, NAF 18703, fol. 86

❧"Colette in her Apartment in the Palais-Royal in 1935", Albert Harlingue, photograph
Estampes et Photographie, N2 (Colette)

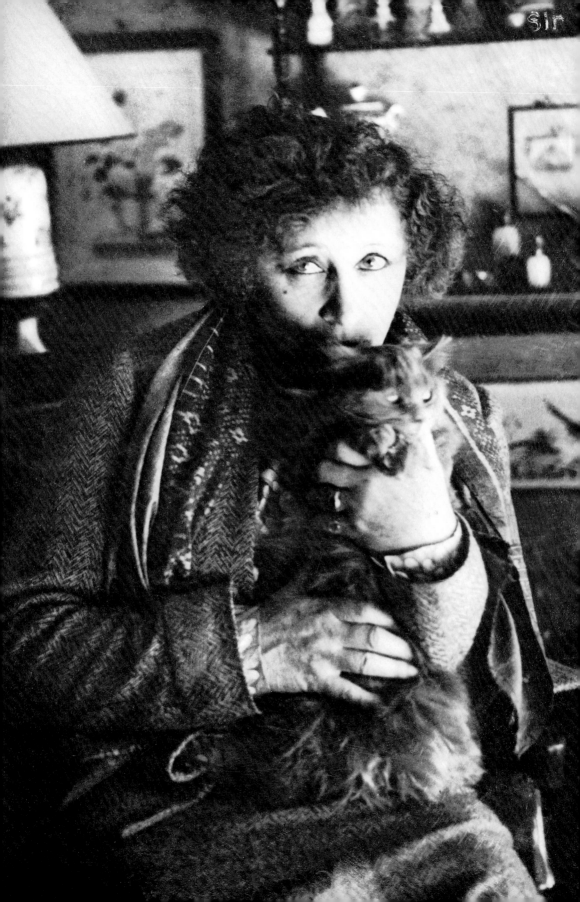

But Colette was the unmatched champion, making the hero of her novel *The Cat* say:

> It wasn't only a little she-cat I brought. It was the nobility of all cats,
> their infinite disinterestedness, their knowledge of how to live, their
> affinities with the highest type of humans.
> (trans. Roger Senhouse, London, Martin Secker and Warburg, 1953)

The cat's triumphal entry into the literary world was the culmination of a long-standing complicity between cats and the "austere scholars/Who like them catch cold and are often sedentary" of Baudelaire's poem. The cat had long since

❧ ❧ "Cats", Jacques Nam (1881–1974), etchings
for *Chats* by Colette (1873–1954), Paris, 1936
Réserve des livres rares, RES ATLAS-Z-11, pl. 5

found its place in libraries. Naturally enough, since it was the most effective enemy of the library rat. Meaning of course the rodent and not the bookworm – the librarian's bête noire – who has no known predator. The abbé Jacques Delille, in his poem "Description of Author's Cat" (*The rural philosopher: or, French Georgics: A didactic poem*; trans. John Maunde, 1801) sang the praises of his deceased cat, longing to see her once again:

> Watching the fly, or on the rat to leap,
> Whose deadly tooth shall never author spare,
> But gnaw alike Du Bartas or Voltaire

In *Le Crime de Sylvestre Bonnard* (1881) Anatole France had one of his characters, an ancient book-lover, harangue his cat:

> Hamilcar, sleepy prince of the city of books, O night watch! [...]
> Heroic, voluptuous Hamilcar, sleep on until the hour when the mice
> dance in the moonbeams in front of the learned Bollandists' *Acta
> sanctorum.**

But Raton and Hamilcar are no mere mouse-catchers. Their silent presence brings comfort and serenity to copyists, writers, and poets: "*A poet's cat, sedate and grave, as poet well could wish to have*", wrote William Cowper in the eighteenth century. Ten centuries earlier, an Irish monk jotted a long ode to his cat in the margin of a manuscript (*The Poetry of Cats*, ed. Samuel Carr, Chancellor Press, 1974, p. 96):

> I and Pangur Ban, my cat,
> 'Tis a like task we are at:
> Hunting mice is his delight,
> Hunting words I sit all night.
> (trans. from the Irish by Robin Flower)

One of the attractions in the house where Petrarch died in 1370, which became a place of literary pilgrimage in the fifteenth century, was the mummy of a cat which had allegedly belonged to the poet. Two centuries later, Torquato Tasso, the author of *Jerusalem Liberated*, took comfort in his wandering and madness in a cat whom he celebrated in an oft quoted sonnet. And Montaigne wrote, in "An Apology for Raymond Sebond" (*Essays*, Book II, chap. XII):

> When I am playing with my cat, who knowes whether she have
> more sport in dallying with me than I have in gaming with her?
> We entertaine one another with mutuall apish trickes.
> If I have my houre to begin or to refuse, so hath she hers.
> (trans. John Florio)

About the same time, Joachim Du Bellay wrote "French verses on the death of a little cat", a long lament for his cat Belaud, which he sent to his friend Olivier de Magny before publishing it as "Epitaph on a Pet Cat" in *Rustic Games** (1558). He thus launched a genre which was to enjoy lasting success: the commemorative poem for cats. In the next century, François Maynard was not too proud to sign a "Epitaph of a Cat". Others followed his lead: Domenico Balestieri (*Lagrime in morte di un gatto*, 1741), Thomas Gray (*Ode on the Death of a Favourite Cat Drowned in a Tub of Gold Fishes*, 1748), Christina Rossetti (*On the Death of a Cat,* ca. 1846), and Thomas Hardy (*Last Words to a Dumb Friend,* 1904). Baudelaire brought a new dimension to cat-loving poetry. Yet he devoted to cats only three sonnets in *Les Fleurs du mal* and one *Little Poem in prose* called "The Clock". With their music in mind, we read with boredom relieved by only the faintest smile variations on the theme by François Coppée, Edmond Rostand, Francisque Sarcey, and even Keats, Swinburne, Mallarmé, Charles Cros, and Jules Laforgue. We might add one unexpected name to the list, that of Hippolyte Taine, the archetypal "austere scholar", whose sonnets to "Puss, Ébène et Mitonne" were published posthumously in *Le Figaro*, against their author's wishes. That is why we are grateful to

T. S. Eliot, Paul Eluard, Robert Desnos, Jacques Prévert and, of course, Raymond Queneau, the author of the lines below from *Beating the bushes* ("Cat, Rat"*), for tweaking the cat back into its native zaniness:

The lazy thermometric cat	Le chat paresseux et thermométrique
Stares the electric heater at.	Regarde le radiateur électrique.

It is perhaps easy, and certainly fun, to give the pen to the cat. Published in 1820–21, *Lebensansichten des Katers Murr* (*Life and Opinions of the Tomcat Murr*) by Ernst Theodor Amadeus Hoffmann, was interrupted by the death of the author shortly after that of his companion, the real-life Murr. Claiming to be the unfinished autobiography of a cat-poet, it is in fact a parody of the novel of apprenticeship in the style of Goethe. The supposed publisher claims to have received *Murr*'s manuscript accidentally mixed up with the biography of its owner, the choir-master Johannes Kreisler, who was Hoffmann's double. A few years earlier, in 1793, one of Hoffmann's friends, Ludwig Tieck, had made a cat into a literary critic in *Der gestiefelte Kater* (*Puss in Boots*). In 1841, Balzac published *The Heartbreak of an English Cat* in *Public and Private Life of Animals* by Pierre Jules Hetzel, who, under the penname of P.-J. Stahl, wrote *Poor Minette; the Letters of Two French Cats* (trans. Julian Jacobs, London, Rodale Press, 1954). The two books read like the memoirs of two cats, Beauty and Minette. The story borders on caricature. As a youth, Hippolyte Taine wrote a surprising *Life and Philosophical Opinions of a Cat*, a short text published in the second edition of *A Tour through the Pyrenees* (trans. J. Safford Fiske [1858]). The writer is a farm-cat and his cruel story strangely prefigures George Orwell's *Animal Farm* (1945), a philosophical tale denouncing Stalinism. Taine's text was probably a disguised criticism of Napoleon III's regime. In Japan, at the end of the Meiji era, Natsume Soseki gave the pen to the razor-clawed companion of an embittered intellectual in *I am a Cat*, published in serial form in 1905–6. The opening lines of the novel, "I am a cat. I don't yet have a name. I have no idea where I was born" are famous in Japan, where the novel

❧"M. Ginguelino", Eugène Delâtre (1864–1938), print
A painter in Montmartre, Eugène Delâtre collected Japanese prints. His first engravings date from 1890. Cats are given pride of place.
Estampes et Photographie, EF-463 (1)

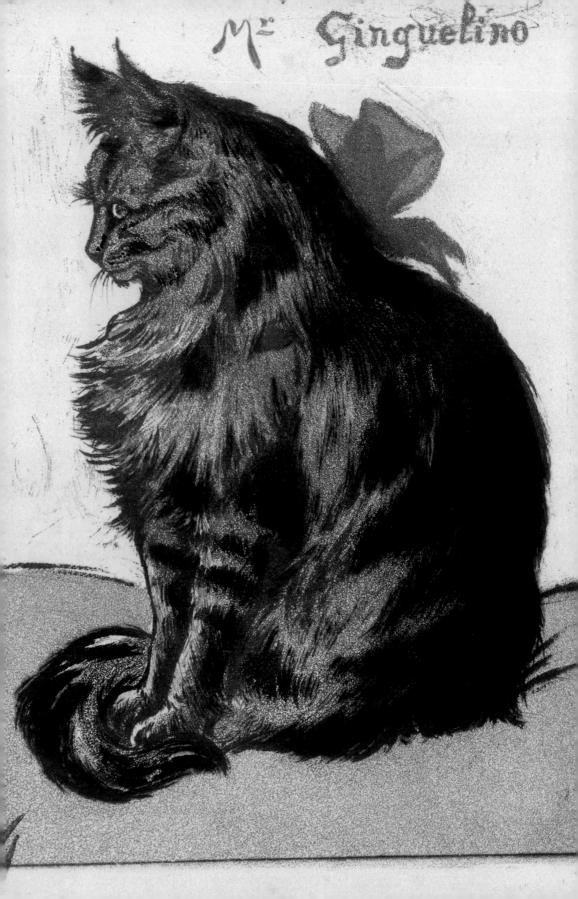

Mr Ginguelino

was twice made into a film, in 1935 and 1975. In *Mel jsem psa a kocku* (I had a Dog and a Cat), published in 1939, a year after the author's death, the Czech writer Karel Čapek gave a cat's slightly contemptuous but affectionate view of his master, a writer in search of inspiration. The traditional version of the genre now seems to have run its course, although Charles-Albert Cingria gave it new impetus in *Le Carnet du chat sauvage*, illustrated by Pierre Alechinsky in 2001. Cingria's cat is a "being of deep culture, great humour and fine manners" according to Jacques Réda ("Cingria zoologique" in *Literary Dogs and Cats*,* p. 11), and goes seamlessly from universal cattiness to the most Genevan humanity.

Making cats, or other animals, talk is a literary device common in fables and tales. Hearing one's cat speak is a fantasy rife among cat-lovers, when the silence of their pets annoys or worries them, like Charles Cros, in *The Sandalwood Chest** ("To a Cat"):

> Why this serenity?
> Do you have the key to the problems
> That obsess us, trembling and pale,
> Through spring and summer?

In a short story by the British writer Saki (pen-name of Hector Hugh Munro, 1870–1916), an eccentric scientist, who is a guest at an elegant country party, tries the technique on the household cat. But, Tobermory, who goes unseen from one room to the next, proves to be a sarcastic witness who does not mince his words, greatly upsetting his aristocratic audience. Tobermory perhaps inspired the Czech filmmaker Vojtěch Jasný for his film *The Cat Who Wore Sunglasses* which won the Special Jury Prize at Cannes in 1963. When the cat's dark glasses are removed, the people in the film take on their real colours (grey for thieves, yellow for the unfaithful, red for lovers). Webster, who flows from the witty pen of P. G. Wodehouse, is a cat entrusted to the impossible Bertie

Wooster by his uncle, an Anglican bishop, High Church, of course. Webster does not talk, because Wodehouse is shyer than his predecessor, Saki, but his disapproving silences and haughty looks force the unfortunate Bertie, already tyrannised by the butler Jeeves, to give up his nocturnal roaming. Lastly, *The Cat Child** by Beatrix Beck tells the story of a little cat given to the narrator, a retired teacher, by a strange old hag. The animal, miraculously gifted with speech, has a yearning to be human and an appetite for the humanities. A series of misadventures follows, and in the end the cat returns to its natural feline state. These few examples show that a talking cat is disconcerting, and can even be dangerous because, unlike the dog, it will not stay in its place. If the cat has a place... the cat in Hieronymus Bosch's triptych *Garden of Delights* in the Prado can be seen strolling out of the Garden of Eden, all on its own, with a mouse in its jaws, heedless of the divine injunction for the brotherhood of the species...

♣♣ "The cat", Sō Shiseki (1716–86), colour wood-cut for *Kokon Gasō* (Collection of paintings of old days and times bygone), Part 2, vol. V, 1771 Manuscrits, Japonais 4652, fol. 5v and 6r

Epilogue

When my eyes, drawn like a magnet
To this cat that I love,
Come meekly back again
And I look inside myself,

I see with amazement
The fire of its pale pupils,
Clear beacons, living opals,
Looking at me fixedly.
(from *Selected Poems of Charles Baudelaire*, trans. Geoffrey Wagner, New York, Grove Press, 1974)

200

Many poets have glorified the cat's eyes, usually less brilliantly than Baudelaire, ("The Cat", *Les Fleurs du mal*) and compared the cat to a sphinx. The verb "to reflect" with its double meaning seems tailor-made for cats' eyes. But the cat answers neither its many admirers nor its few miserable detractors. And its eyes reflect no image but theirs. As Eluard wrote ("Cat", *Animals and their Men**):

The cat dances
Just to isolate its prison
And its thoughts
Stop at the wall of its eyes.

There is no denying it, described or derided, loved or loathed, he is the Cat that walks by himself.

❧ "The Cat that Walked by Himself", Rudyard Kipling (1865–1936), *Histoires comme ça pour les petits*, illustration by the author, trans. Robert d'Humières and Louis Fabulet, Paris, Delagrave, 1941
Littérature et art, 8-Y2-26667

"THIS is the picture of the Cat that Walked by Himself, walking by his wild lone through the Wet Wild Woods and waving his wild tail."

ACKNOWLEDGEMENTS

This work is a bundle of skills and efforts bound together by a shared passion for its subject, or rather its hero, the cat.

I am most grateful to Pierre Rosenberg of the Académie Française, who graciously agreed to preface the book with humour and erudition. Nobody could be better qualified for the task than the author of *The Painted Cat*, 1988. My thanks also go to his assistant, Claudine Lebrun.

At the Bibliothèque nationale de France, I benefited from the moral support and knowledge of my colleagues. I would first like to thank Bruno Racine, president of the BNF, Jacqueline Sanson, general manager, Denis Bruckmann, head of collections, M. Thierry Grillet, head of cultural diffusion, and Jocelyn Bouraly head of the publications and sales department.

My gratitude naturally goes to Thierry Delcourt, director of the *Département des Manuscrits*, Marie-Laure Prévost head of the modern and contemporary manuscripts section and Sylvie Aubenas, director of the *Département des Estampes et de la Photographie*, all three practising cat-lovers.

I am indebted to many colleagues at the BNF who gave me advice and information: Gisèle Lambert, Maxime Préaud, Marie-Hélène Petitfour, and Anne-Marie Sauvage in the *Département des Estampes*, Mathilde Avisseau-Broustet in the *Département des Monnaies, Médailles et Antiques*. Jean-Pierre Aniel, Marie-Thérèse Gousset and Nicole Fleurier set off in search of cats, marginal or otherwise, in illuminated manuscripts; Clément Pieyre, Catherine Faivre d'Arcier and Marie-Laure Prévost hunted them down in contemporary manuscripts; and Véronique Béranger, Keiko Kosugi and Annie Vernay-Noury scoured the oriental collections to the same ends. I could not forget François Avril, honorary general curator in the *Département des Manuscrits*, a renowned specialist in medieval illumination and a committed cat-fancier, whose friendly and knowledgeable support has been precious to me for over fifteen years.

Lastly, many thanks to Marie-Françoise Damongeot, Marie-Odile Germain, and Clément Pieyre for their attentive, good-natured copyreading.

In the publications department of the BNF, Pierrette Crouzet-Daurat spent long hours with undying enthusiasm on this project, which she directed with our Italian co-publisher Paola Gallerani – to whom we owe a very fine design – supervising the choice of the illustrations and the consistency of the translations. Their painstaking rereading of the text has been most valuable. I am keenly grateful to them both, as well as to Khadiga Aglan and Ludovic Battu, who followed up the iconography, without forgetting Frédérique Savonna and Philippe Salinson in the reproduction department.

Isabel Ollivier's English version is both faithful and witty, while Paola Gallerani threw herself passionately into the Italian translation with the same success.

Many thanks to Jean-Pierre Andrevon, who, in response to Clément Pieyre's request, graciously gave one of his drawings to the BNF.

Lastly I wish to thank Suzanne Daurat, Giovanna Citi-Hebey, Pascal Massoni, and Sophie Sacquin-Mora for their help in various ways.

❧ "A Cat walking down the stairs", Frans Masereel (1889–1972), xilograph for *La Ville,* Paris, Albert Morancé, 1925
Estampes et Photographie, EF-482-4

SELECTED BIBLIOGRAPHY
IN CHRONOLOGICAL ORDER

FRANÇOIS-AUGUSTIN PARADIS DE MONCRIF, *Cats*, trans. Reginald Bretnor, Golden Cockerel Press, 1961 [1727].

JEAN GAY, *Les Chats, extraits de pièces rares et curieuses en vers et en prose*, Paris, published by the author, 1866.

JULES HUSSON called CHAMPFLEURY, *The Cat, Past and Present, translated by Mrs Cashel Hoey*, A facsimile reprint from the 1885 edition with the original woodcuts The Echo Library, 2005 [1869].

GASPARD-GEORGES-PESCOW, marquis de Cherville, *Les Chiens et les chats d'Eugène Lambert*, prefaced by a letter by Alexandre Dumas [...] biographical notes by Paul Leroi. Illustrated with 6 etchings and 145 drawings by Eugène Lambert, Paris, Librairie de l'art, 1888.

MARIUS VACHON, *Cats and Kittens*, illustr. by Henriette Ronner, trans. Clara Courtenay Bell, Cassel and Co., 1894 [1894].

GEORGES DOCQUOIS, *Bêtes et Gens de lettres*, Paris, Flammarion, 1896.

THÉOPHILE STEINLEN, *Des Chats*, Paris, Flammarion, 1898. 26 "dessins sans paroles" initially intended for the *Revue du Chat noir* by Rodolphe Salis.

GEORGES LECOMTE, *Steinlen. Chats et autres bêtes. Dessins inédits*, Paris, Eugène Rey, 1933.

PAUL MÉGNIN, *Notre ami le chat : les chats dans les arts, l'histoire, la littérature, histoire naturelle du chat, les races de chats, chats sauvages, chats domestiques, les maladies des chats, le chat devant les tribunaux, chats modernes*, preface by François Coppée, Paris, J. Rothschild, 1899.

ATHENAÏS MICHELET, *Les Chats*, introduction and notes by Gabriel Monod, Paris, Flammarion, 1902, Paris, La Part Commune, 2003.

CHRISTABEL ABERCONWAY, *A Dictionary of Cat Lovers, XV century B.C.-XX century A.D* London, Michael Joseph, 1949.

MARCEL UZÉ, *The Cat in Nature, History and Art*, trans. Helen Slonim, Milan, Uffici Press, s.d. [1951].

GERMAINE MEYER-NOISEL, "Le Chat dans l'ex-libris", dans *L'Ex-libris français*, 4th quarter 1952, n° 29.

FERNAND MÉRY, *The Life, History, and Magic of the Cat*. trans. Emma Street. New York, Madison Square Press, 1968 [1966].

FRANCIS KLINGENDER, *Animals in Art and Thought to the End of the Middle-Ages*, London, Routledge and Kegan Paul, 1971.

CLAIRE NECKER, *Four Centuries of Cat-Books*, Metuchen, New Jersey, Scarecrow Press, 1972.

SAMUEL CARR ed., *Poetry of Cats*, London, Batsford, 1974.

KENNETH CLARK, *Animals and Men: Their Relationship as Reflected in Western Art from Prehistory to the Present Day*, London, Thames and Hudson, 1977

JULIETTE RAABE, *La Bibliothèque illustrée du chat*, Paris, La Courtille, 1977.

MICHÈLE PROUTÉ, "Le Chat de Mademoiselle Dupuy", in *La Gazette des Beaux-Arts*, September 1979.

JOHN P. O'NEILL, *Metropolitan Cats*, New York, Metropolitan Museum of Arts / H. N. Abrams, 1981.

The dates of the original French edition are given in square brackets

Louis Nucera, *Les Chats, il n'y a pas de quoi fouetter un homme*, Paris, Scarabée, 1984.

Marcel Bisiaux and Catherine Jajolet, *Chat Plume, 60 écrivains parlent de leur chat*, Paris, Horay, 1985.

Jacques Pierre, *Le Chat et les Artistes, anthologie*, Angers, La Taverne aux poètes, 1985.

Elizabeth Foucart Walter and Pierre Rosenberg, *The Painted Cat: the Cat in Western Painting from the Fifteenth to the Twentieth Century*, New York, Rizzoli, 1988 [1987].

Annie de Montry, *Chat Pub. Cent ans d'images de chats dans la publicité*, Paris, Aubier, 1988.

Dominique Buisson and Christophe Comentale, *Le Chat vu par les peintres, Inde, Corée, Chine, Japon*, Paris, Lausanne, Vilo / Édita, 1988.

Juliet Clutton-Brock, *The British Museum Book of Cats, Ancient and Modern*, London, British Museum Press, 1988.

Pierre Faveton, *Le Chat*, Paris, Ch. Massin, 1988.

Michael I. Wilson, *V & A Cats*, London, Victoria and Albert Museum Publications, 1990.

Fabio Amadeo, *Le Chat, Art, Histoire, Symbolisme*, Paris, R. Laffont, 1990.

François Fossier, *Steinlen Cats, with Artwork from the Collections of the Bibliothèque nationale*, New York, H. N. Abrams, 1990.

Laurence Bobis, *Les Neuf Vies du chat*, Paris, Gallimard, 1991.

Mark Bryant, *The Artful Cat*, London, Apple Press, 1991.

John Nash, *Cats,* Paris, London, RMN / Zwemmer, 1992.

Kathleen Alpar-Ashton, *Histoires et légendes du chat*, preface by Leonor Fini, Paris, Tchou, 1973.

Robert de Laroche, *The Secret Life of Cats,* trans. Jean-Michel Labat, Hauppauge, NY, Barron's, 1995 [1993].

Luc Ferry and Claudine Germé, *Des animaux et des hommes, anthologie des textes remarquables, écrits sur le sujet, du XVe siècle à nos jours*, Paris, Librairie générale française, 1994.

Michèle Sacquin, *Chats de bibliothèque*, Paris, Albin-Michel, 1995.

Donald Engels, *Classical Cats. The Rise and Fall of the Sacred Cat*, London and New York, Routeledge, 1999.

Laurence Bobis, *Le chat, histoire et légendes*, Paris, Fayard, 2000.

Jacques Réda, Jacques Berchtold, Jean-Carlo Flückiger, *Chiens et chats littéraires chez Cingria, Rousseau et Cendrars*, Genève, La Dogana, 2002.

James Henry Rubin, *Impressionist Cats and Dogs: Pets in the Painting of Modern Life*, Yale, Yale University Press, 2003.

Laurence Bobis, *Une histoire du chat de l'antiquité à nos jours*, Paris, Le Seuil, 2006.

Elizabeth Foucart-Walter and Frédéric Vitoux, *Cats in the Louvre* Paris, London, Flammarion/ Thames & Hudson, 2007.

Frédéric Vitoux, *Bébert ou Le chat de Céline*, Paris, Grasset, 2008.

Frédéric Vitoux, *Le Dictionnaire amoureux du chat*, Paris, Plon, 2008.

PHOTO CREDITS

The asterisk denotes that the titles cited do not exist in an English version. The dates between brackets are those in the original French editions.

Unless otherwise stated, all quotations are translated by Isabel Ollivier.

MICHÈLE SACQUIN
Chief Curator in the Département des Manuscrits of the Bibliothèque Nationale de France, archivist and palaeographer, doctor in History, author of *Printemps des génies*, Paris, BN/Laffont, 1993; *Chats de bibliothèque*, Paris, Albin Michel, 1995; *Entre Bossuet et Maurras. L'antiprotestantisme en France, 1814–1872*, Paris, Champion, 1998; *Zola. Cent ans après*, Paris, BNF/Fayard, 2002.

♣ Invitation to an exhibition and envelope illustrated with a cat, Théophile Steinlen (1859–1923), 1903
Estampes et photographie, DC-385 FOL, t. 5

♣♣ "Half past six! Who has forgotten my breakfast?" Jean-Pierre Andrevon, drawing for *Les Chats d'Andrevon*, 1991
Manuscrits, fonds Jean-Pierre Andrevon, NAF 28101

Six heures et demi !
Qui c'est qui oublie
mon petit-déjeuner ?

This book was composed in Poetica typeface for the titles,
Souvenir for the body text, and Foundry Sterling for the captions.
Printed on Simbol Free Life Satin Fedrigoni 130 gr. FSC
on the presses of Varigrafica, Rome
in the month of September 2013
ex Officina Libraria Jellinek et Gallerani

© 2010 - Bibliothèque nationale de France, Paris
© 2010 - Officina Libraria s.r.l., Milan
ISBN BNF: 978-2-7177-2469-1
ISBN Officina Libraria: 978-88-89854-56-3
www.bnf.fr
www.officinalibraria.com

Printed in Italy

Two versions were published
of the same book
one in French
Des chats passant parmi les livres
and one in Italian
Gatti di Biblioteca

ANDREVON